IMAGES
of America

SAVANNAH
1733 TO 2000
PHOTOGRAPHS FROM THE COLLECTION OF
THE GEORGIA HISTORICAL SOCIETY

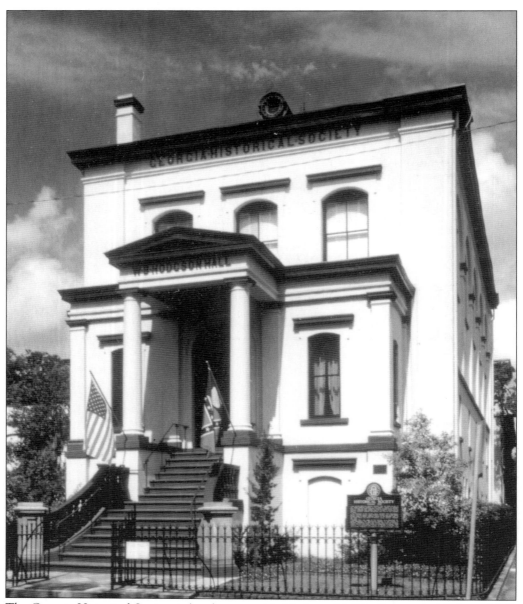

The Georgia Historical Society is headquartered in Hodgson Hall in Savannah. Hodgson Hall, named for William B. Hodgson, became the third home of the Society in September 1875. The building was officially dedicated on February 14, 1876, and has been the Society's statewide headquarters ever since. Housed within Hodgson Hall is one of the finest library collections of manuscripts, archives, books, photographs, newspapers, architectural drawings, portraits, maps, and artifacts relating to the state of Georgia. The library is free and open to the public. Hodgson Hall is located at 501 Whitaker Street, Savannah, Georgia, 31401.

IMAGES
of America

SAVANNAH
1733 TO 2000
PHOTOGRAPHS FROM THE COLLECTION OF THE GEORGIA HISTORICAL SOCIETY

Susan E. Dick and Mandi D. Johnson

ARCADIA

Published by Arcadia Publishing,
an imprint of Tempus Publishing, Inc.
2 Cumberland Street
Charleston, SC 29401

Printed in Great Britain.

Library of Congress Catalog Card Number: 2001087664

For all general information contact Arcadia Publishing at:
Telephone 843-853-2070
Fax 843-853-0044
E-Mail sales@arcadiapublishing.com

For customer service and orders:
Toll-Free 1-888-313-2665

Visit us on the internet at http://www.arcadiapublishing.com

CONTENTS

THE GEORGIA HISTORICAL SOCIETY

Chartered by the Georgia Legislature in 1839, the Georgia Historical Society is a private, non-profit organization that serves as the historical society for the entire state of Georgia. For more than 160 years, the Society has fulfilled its mission to collect, preserve, and share Georgia's history through the operation of its library and archives in Savannah. The Society exists to tell the story of our state's journey through time and to give our citizens a sense of who we are as Georgians.

The Georgia Historical Society is headquartered in Savannah in historic Hodgson Hall and is a major research center serving approximately 10,000 researchers of Georgia history per year. Within the Society's library and archives is preserved one of the most outstanding collections of manuscripts, archives, books, photographs, newspapers, architectural drawings, portraits, maps, and artifacts related to Georgia history anywhere in the country. The Society is continually adding to its collections through both donations and purchases.

In addition to its magnificent library, the Georgia Historical Society has a statewide outreach program. The Society accomplishes this mission in a variety of ways and to a wide audience. The Society conducts lectures and historical programs, administers the State Historical Marker Program, and most significantly, has a statewide Affiliate Chapter Program. This program is the foundation upon which all statewide outreach is built.

The Affiliate Chapter Program encourages historical agencies and interested parties throughout the state to join the Georgia Historical Society in our mission to save Georgia history. Through this professional education program, the Society provides assistance, holds teacher workshops, and serves as an information clearinghouse for those historical agencies in need of help or advice. Staff members visit these organizations and conduct consultation visits offering assistance in everything from archival management and administration to securing grant funds. The Affiliate Chapter Program, more specifically the workshops conducted as part of the program, were awarded the 1997 Professional Development Program of the Year by the Georgia Association of Museums and Galleries.

In addition to the Affiliate Chapter Program, the Georgia Historical Society organizes the Georgia Heritage Celebration, which is held every February and is a time for us to remember the founding of our state. The celebration is directed at schoolchildren with research and colonial costume workshops, colonial town meetings, and a parade from Forsyth Park up Bull Street to City Hall.

The Georgia Historical Society publishes the *Georgia Historical Quarterly* with cooperation from the Georgia College and State University in Milledgeville. The *Georgia Historical Quarterly* has become one of the country's leading scholarly journals dedicated to a particular state. In 1840, the Society began publishing books with items from the collection. This is an ongoing activity at the Georgia Historical Society and this book is a continuation of that program.

INTRODUCTION

Savannah was Georgia's first city and remains unique in the state. Unlike Atlanta to the west, which has long been considered the icon of the New South, Savannah has retained much of its traditional Old South feel: graceful homes on streets lined with live oaks and magnolias; the scent of tea olives and jasmine; the rich palettes of azaleas and camellias; and generous, welcoming people. In fact, Savannah is known as the hospitality city; the adage goes that "In Atlanta, they ask where you work. In Macon, they ask what church you go to. In Augusta, they ask who your grandparents were. In Savannah, they ask what you want to drink."

Savannah, Georgia, was founded on February 12, 1733, by Gen. James E. Oglethorpe and 114 colonists who traveled aboard the *Anne* from Gravesend, England. Although Georgia was founded as a buffer colony for South Carolina against Spanish Florida, the city of Savannah quickly established itself as an important commercial and social city. Throughout the decades the city has experienced difficult times as well as periods of peace and prosperity. Savannah's location at the mouth of the Savannah River made it one of the largest seaports on the east coast, exporting cotton, rice, naval stores, ships, and other agricultural goods. Twentieth-century Savannah has been dominated by the development of industry as well as the historic preservation movement and the resulting historical tourism economy.

The authors recognize that Savannah is a large city with many distinctive neighborhoods and outlying areas. For the purposes of this book, we have chosen to focus largely on the Historic District, bound on the north by the Savannah River, the west by Martin Luther King Boulevard, the south by Gaston Street, and the east by East Broad Street. The historic district measures 2.2 square miles, making it the largest on the Register of National Historic Landmarks. Although much of Savannah's charm is found in her lush squares and magnificent buildings, the history of her citizens is equally captivating. By exploring the city's institutions and events, we hope to present a broader picture of life in Savannah.

Drawing from the vast visual image collections of the Georgia Historical Society, *Savannah: 1733 to 2000*, illustrates the many facets of life in Georgia's first city. With more than 200 photographs, maps, portraits, and prints of Savannah, we have tried to combine visually appealing images with informative captions to capture the long and rich history of Savannah. Finally, in the words of Mr. William Harden, librarian and historian, the authors, "crave the indulgence of the reader in the matter of any defects which may be discovered."

ACKNOWLEDGMENTS

The authors wish to thank the staff of the Georgia Historical Society for their help and patience during this project. In particular, we would like to recognize Vincent X. Ford for his help photocopying and Stan Deaton for coming to our rescue with an illusive image. We thank Candy Baxter for her assistance proofreading. For her help photographing the squares, we thank Abby Johnson. And for his editorial suggestions, we are indebted to Steve Hoffius. Our ultimate gratitude is reserved for Mr. William Harden, whose voluminous knowledge of the history of Savannah is without parallel.

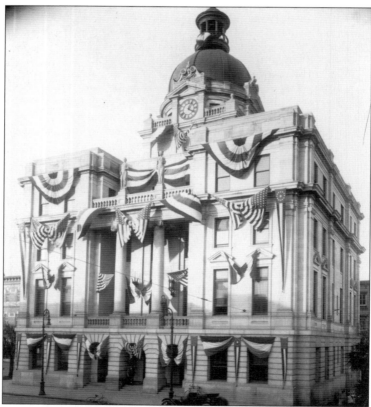

City Hall is decorated with bunting for President William Taft's visit.

One
HISTORIC SAVANNAH

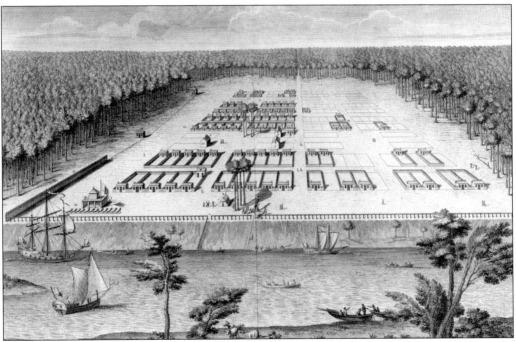

"A view of Savannah as it stood the 29th of March 1734. To the honorable the Trustees for establishing the colony of Georgia in America this view of the town of Savannah is humbly dedicated by their honours.(sic) Obliged and most obedient servant, Peter Gordon." Peter Gordon's map of Savannah is the earliest known rendering of the city of Savannah. The view captures the bluff on which the city was placed, 40 feet above the river, as well as the surrounding timberland. In the foreground is Gen. James E. Oglethorpe's tent, which was his command post while he was in Savannah.

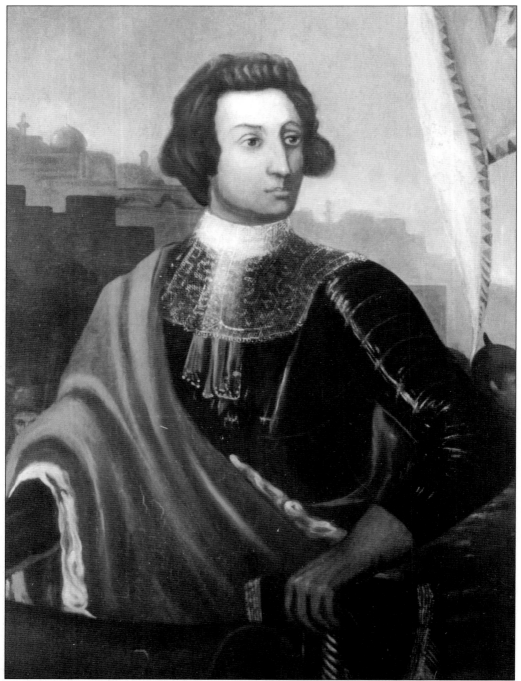

Gen. James E. Oglethorpe was 37 years old when he founded Georgia as the 13th American colony of the British crown. As a young man, Oglethorpe was interested in penal reform, particularly debtors' prison reform. Contrary to popular belief, Georgia was not established as a colony for debtors or convicts; while most of the colonists were poor and even in debt, none had been in debtors' prison.

The colonists stopped first in Charlestown and Beaufort, South Carolina, while Oglethorpe scouted a location for the town. He entered into a treaty with Tomochichi, Mico (or chief) of the Yamacraw Indians, the only tribe in the area. Tomochichi was a lifelong friend to the colony, even visiting the trustees and the king in 1734 with Oglethorpe. This portrait of Tomochichi and his nephew Toonahowi was painted in England during this visit. Upon his death, Tomochichi was afforded a state funeral. His grave is marked with a granite boulder in Wright Square.

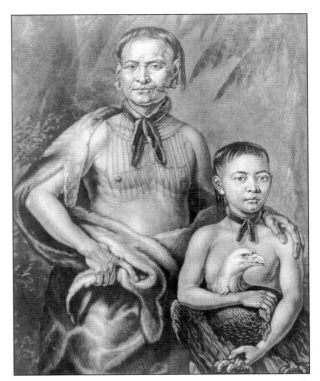

Named for George II, Georgia was colonized to create a buffer state to protect South Carolina—Charlestown in particular—from Spanish Florida. In 1736, Oglethorpe established Fort Frederica as Georgia's southern defense on St. Simons Island. The fort, seen here c. 1904, was named for Frederick, Prince of Wales, the eldest son of George. A short time after the fort was established, England and Spain became involved in what was known as the War of Jenkins' Ear. English smuggler Thomas Jenkins was captured by the Spanish, who cut off his ear and told him to show it to the king. Jenkins presented his ear to Parliament as a sign of how poorly the British were treated by the Spanish. Oglethorpe led English troops against Spanish Florida and won the war with a major victory at the Battle of Bloody Marsh where approximately 500 Spanish troops died.

Among the original colonists was Noble Jones, who served as the first colonial surveyor, laying out the city according to Oglethorpe's plan of squares. He also served the colony as doctor, carpenter, and constable in addition to serving on the Royal Council for 18 years. Because Noble Jones was one of the few to pay his passage and that of indentured servants as well, he received a grant of 500 acres, which was the most possible at that time. He established a plantation named Wormsloe on this land, located on the Isle of Hope. The first structure was a wooden fort overlooking the Vernon River. The remains of Wormsloe Plantation are open to the public through the Georgia State Park system.

As the official surveyor for the colony, Jones was called upon to lay out the settlement of Ebenezer and Augusta. Ebenezer, seen here in this painting by W. Fitler, was the first site chosen by the Salzburgers in March 1734, shortly after their arrival in the colony. Salzburgers were Lutherans from the Salzburg area in Austria, who fled religious persecution at the hands of Catholics. After finding their first choice of settlement disagreeable, they relocated six miles to the east to New Ebenezer around 1737.

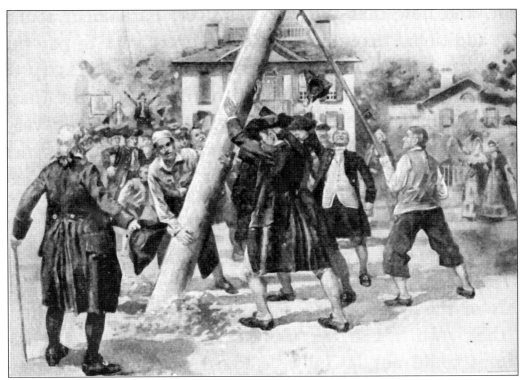

After the 1765 Stamp Act, rebellion was afoot in England's colonies, including Georgia. At Peter Tondee's tavern—on the northwest corner of Whitaker and Broughton Streets—the Sons of Liberty, or Liberty Boys, gathered to air their grievances against the crown. In June 1775, the Liberty Pole in Johnson Square was raised "by those who did not believe in his [George III] treatment of his subjects on this side of the Atlantic."

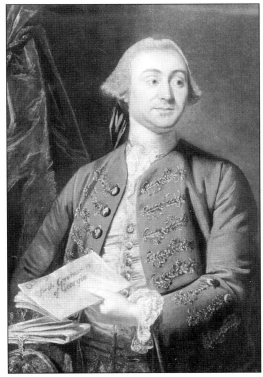

James Wright was born c. 1714 in Charlestown, South Carolina, where he practiced law. He also served as agent of South Carolina in Great Britain and in 1760 was made governor of Georgia by royal appointment. Wright was a popular governor until the Revolutionary period, when he was placed under house arrest in 1775. He subsequently escaped to England. After Savannah fell to the British, Wright was reinstated as governor until 1782 when the British forces withdrew. Wright returned to England where he died in 1785.

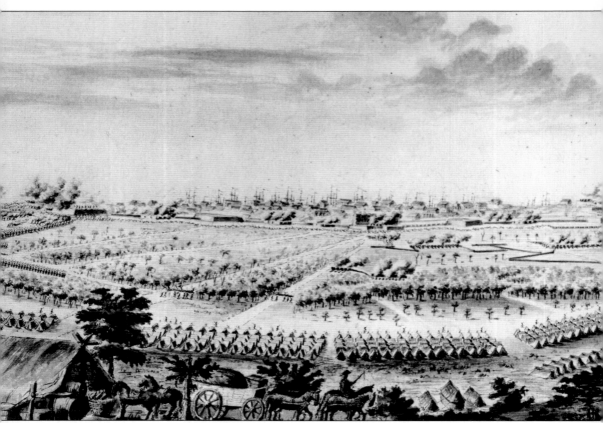

In December 1778, Savannah fell to the British, who were under the command of Archibald Campbell. In September 1779, the French Admiral Charles-Henri d'Estaing arrived with 22 ships and several thousand troops to liberate the city. The French and American troops joined forces and laid siege to Savannah on October 9, 1779. The battle was the second bloodiest in the Revolutionary War with approximately 750 wounded and dead French and Americans, and only 57 British wounded and dead. "View of the city of Savannah, trenches and attack, October 1779" was painted by Pierre Ozanne, a French naval officer who accompanied d'Estaing specifically to document the attack. (Original in the Library of Congress.)

One of the casualties of the
Battle of Savannah was Polish
Count Casimir Pulaski. Pulaski
joined the Revolutionary forces
and was soon commissioned a
brigadier general. Pulaski
commanded the cavalry troops of
Benjamin Lincoln and Comte
d'Estaing. Leading a charge
during the battle for Savannah,
Pulaski was mortally wounded by
a grapeshot to the upper thigh.
He died aboard the brig *Wasp* on
October 11, 1779.

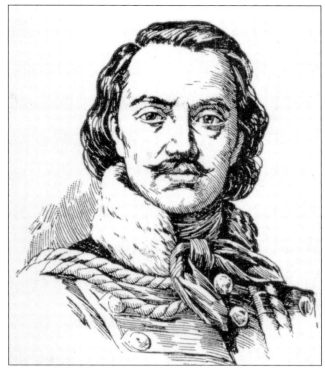

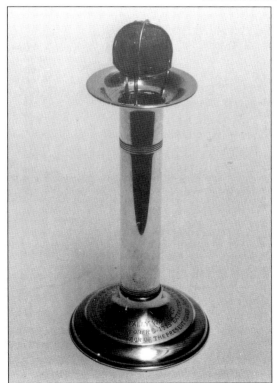

In the collections of the Georgia
Historical Society, mounted on a silver
pedestal, is an artifact identified as the
"Grapeshot which mortally wounded
Count Casimir Pulaski, October 9, 1779,
extracted from his body by Dr. James
Lynah, ancestor of present owner, James
Lynah, Esq."

15

Fourteen miles northwest of the city on the Savannah River lies the remains of Mulberry Grove Plantation, so named for the mulberry trees which were grown there as part of Georgia's silk experiment. Following the Revolution, Mulberry Grove was confiscated from loyalist John Graham and given to Gen. Nathanael Greene as reward for his service to Georgia during the war. Greene lived here with his wife, Catherine, and their children until he died of heat stroke in 1786. This sketch was drawn in 1911.

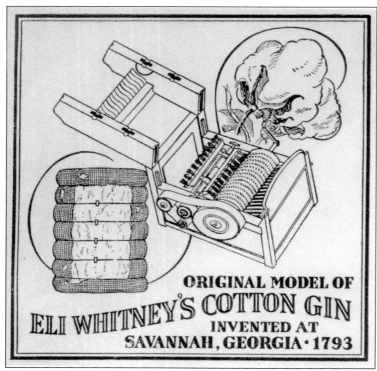

ORIGINAL MODEL OF ELI WHITNEY'S COTTON GIN INVENTED AT SAVANNAH, GEORGIA · 1793

In 1793, Eli Whitney, while a tutor to the Greene children at Mulberry Grove, invented the cotton gin, revolutionizing the cotton industry and paving the way for the reign of "King Cotton" in Georgia.

In 1791, President George Washington conducted his southern tour, stopping in Savannah May 12 through May 15. Washington attended services at Christ Church, dined at Brown's Coffeehouse, toured the Revolutionary ruins at the Spring Hill redoubt on Savannah's westside, attended a ball at the Filature on Reynolds Square, and dined with Nathanael Greene's widow, Catherine, at Mulberry Grove before heading to Augusta. While in Savannah, Washington stayed at this house, now demolished, on the northwest corner of Barnard and State Streets.

Another Revolutionary War hero to visit Savannah was the Marquis de Lafayette (Marie Joseph Paul Yves Roch Gilbert du Motier). While on his American tour in 1825, Lafayette stopped in Savannah and was asked to lay the cornerstone of the monument in Johnson Square, originally intended to honor both Nathanael Greene and Casmir Pulaski. This monument was later renamed to honor Greene alone. (Image from the *Magazine of American History*, December 1878.)

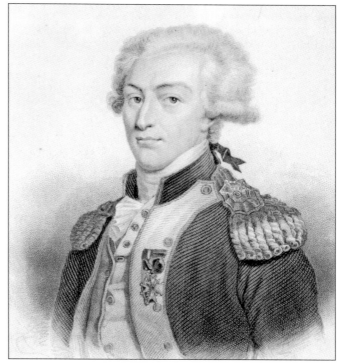

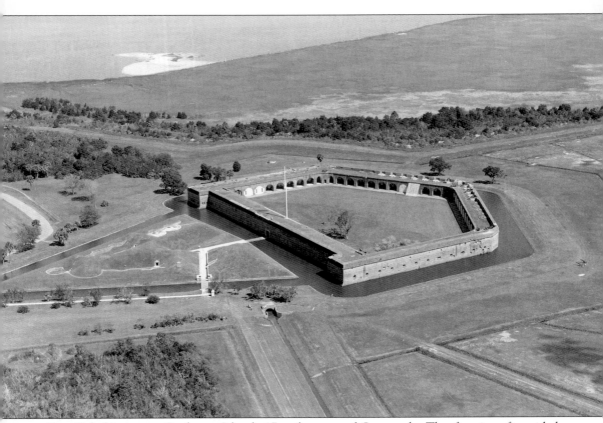

Fort Pulaski sits on Cockspur Island, 17 miles east of Savannah. The fort is a five-sided brickwork, covering two-and-a-half acres, surrounded by a moat. Fort George was the first fort on Cockspur Island, built in 1761 to protect Savannah during the French and Indian War. It was abandoned in 1776 and replaced with Fort Greene, built in 1794–1795 and destroyed in the hurricane of 1804. Plans for the current fort, Pulaski, were drawn as early as 1827. Built between 1829 and 1847 as part of an Atlantic Coast defense system, Fort Pulaski was christened in 1833.

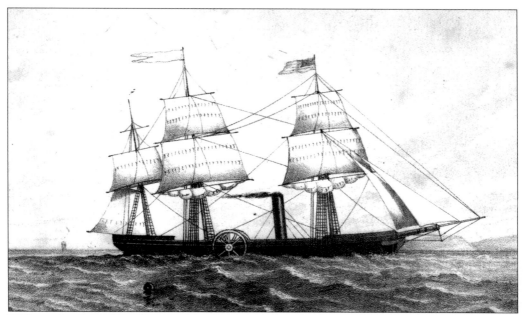

William Scarbrough was born in Beaufort, South Carolina, and educated in Europe. He arrived in Savannah around 1798 and became one of the city's "merchant princes." Among his many business interests was the Savannah Steamship Company, which he served as president. Departing from Savannah on May 22, 1819, and arriving in Liverpool on June 10th, the SS *Savannah* was the first steamship to cross the Atlantic Ocean. Among the many dignitaries on hand to witness the historic departure was President James Monroe. Built in New York, the ship was an "auxiliary clipper," rigged for sailing with a single steam engine and paddle wheel. In November 1821, the SS *Savannah* beached and was totally destroyed on New York's Fire Island.

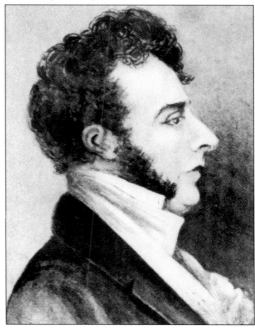

Capt. Moses Rogers was the skipper who led the SS *Savannah* on her maiden voyage. Originally from New London, Connecticut, Rogers is buried in Cheraw, South Carolina. Two years after his historic voyage as captain of the SS *Savannah*, he died of malaria while operating a steamboat on the Pee Dee River between Cheraw and Georgetown, South Carolina.

Fermin Cerveau's "1837 View of Savannah" is the city's most famous portrait. Perched high in the tower of the City Exchange, Cerveau captured the hustle and bustle of this busy seaport. The brilliance of the painting is in its detail, which allows the viewer to see dry goods in

merchants' shops, the styles of carriages making their way through the city's streets, and the
activities of people seen in windows and backyards. Cerveau's "1837 View of Savannah" is on
display in the reading room of the Georgia Historical Society.

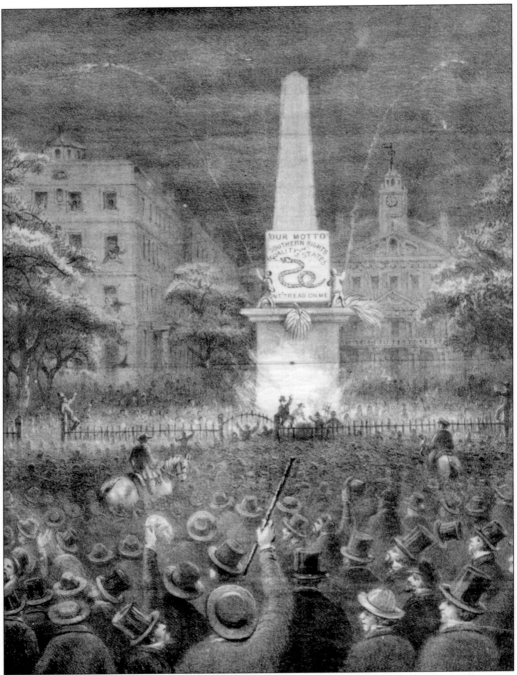

In the decades between 1837 and 1861, Savannah prospered in an economy based on slave labor. Issues of states' rights and slavery culminated in the 13 southern states' rejection of their ties to the Union. On December 20, 1860, South Carolina became the first southern state to secede from the Union. The news was received in Savannah "with the greatest delight." On January 19, 1861, Georgia became the fifth state to secede.

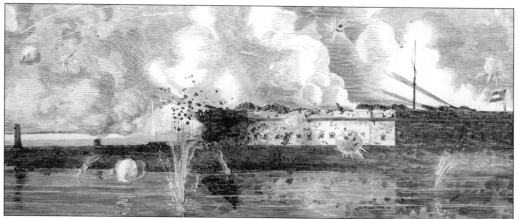

Fort Pulaski was a Federal fort until January 1861, when it was taken by Georgia governor Joseph Brown and turned over to the Confederate States of America without a shot being fired. The fort was deemed to be impenetrable, with brick and masonry walls 32 feet high and between 7 and 11 feet thick. However, in April 1862, Union troops assaulted the fort with rifled cannon fire, a recently developed weapon that devastated the masonry walls. Thirty hours after it began the assault concluded with the surrender of Fort Pulaski. Used as a Union garrison for Confederate troops during the war, it was effectively abandoned by 1885. In 1933, it became a National Park site.

After years of a brutal civil war, the battlefield crept into the heart of the South. Gen. William T. Sherman began his strategy of "total warfare" when he commenced his March to the Sea in the fall of 1864. Sherman's troops burned and looted communities from Atlanta to the coast in an effort to demoralize the citizenry, thus undermining support for the war. His units reached Savannah in December 1864. Mayor Richard D. Arnold surrendered the city to Gen. John W. Geary. On December 25, 1864, Sherman telegraphed President Lincoln, "I beg to present to you as a Christmas gift the city of Savannah." From December 1864 until the end of the war, Union troops occupied Savannah.

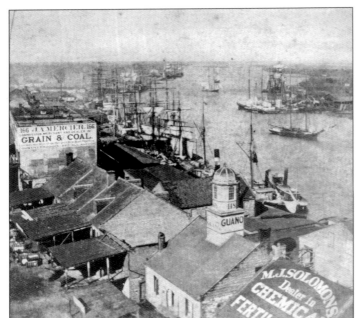

In the years following the Civil War, Savannah and the South adjusted to the economic and social changes of Reconstruction. During the 1870s through the 1890s, the plantation economy began to shift to an industrial base. Timber, naval stores, and other manufactured goods replaced cotton and rice as the major exports from Savannah. This *c.* 1883 image shows the harbor busy with ships.

Florence Margaret Martus was born in 1868 on Cockspur Island and lived her whole life on the Savannah River. Her father was the ordnance sergeant for Fort Pulaski, where she grew up. Later she lived with her brother George W. Martus, the lighthouse keeper on Elba Island. Better known as the "Waving Girl," Martus greeted incoming and outgoing ships by waving a handkerchief by day and a lantern by night. She didn't miss a single ship between 1887 until 1931, when George retired as lightkeeper and the pair moved into town. Her "retirement" was noted even in the London newspapers. A statue on River Street commemorates her legacy.

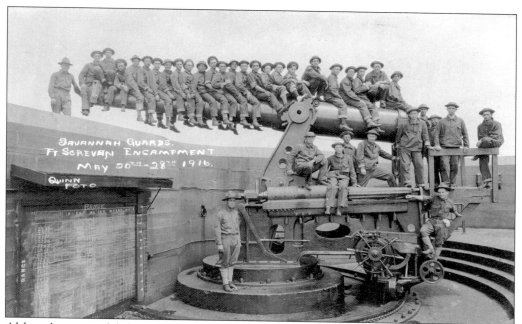

Although state and federal legislation dating back to 1786 provided for a fort on Tybee Island to be named in honor of Revolutionary War hero Gen. James Screven, it was 1898 before Fort Screven was established. From the Spanish-American War until World War II, the fort served as a training facility for U.S. troops.

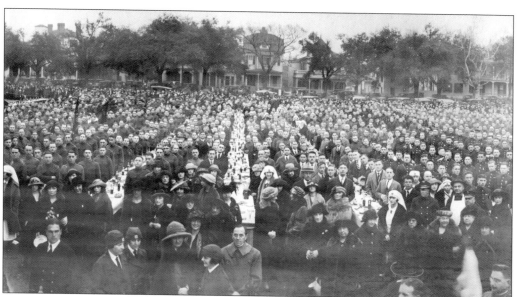

On February 7, 1923, the last U.S. troops of World War I returned from the Rhine. Savannah greeted the soldiers with a welcoming committee at the dock, a city-wide parade, and an "Old Fashioned Georgia Barbeque" in Forsyth Park.

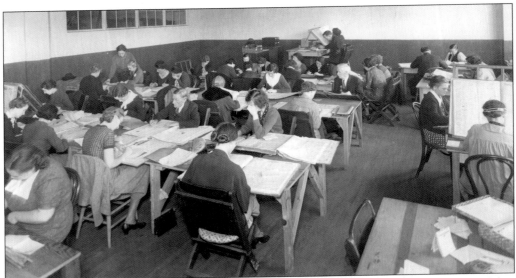

In April 1934, the Savannah Historical Research Association was organized and, in May of that year, agreed to oversee workers of the Civil Works Administration, which later became known as the Works Progress Administration. The Historical Records Survey workers of the WPA, seen here, were engaged in indexing the *Savannah Morning News*, the *Colonial Records of Georgia*, and other county and civic records.

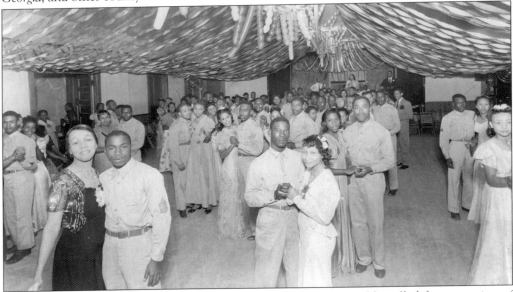

At an informal meeting in November 1940, Mayor Thomas Gamble called for a meeting of citizens "for the purpose of considering a program of recreation for the enlisted men who will be stationed at the Savannah Air Base, Fort Screven, Camp Stewart, and the Marines at Parris Island [SC]." In February 1941, the Soldiers Social Service of Savannah began operations and eventually opened three centers in the city: two for white soldiers and one for African Americans. The SSSS offered wholesome entertainment for its guests, including dances, theater performances, home-cooked meals, crafts, and other recreational activities. Between 1941 and 1945, approximately 3 millions soldiers were accommodated.

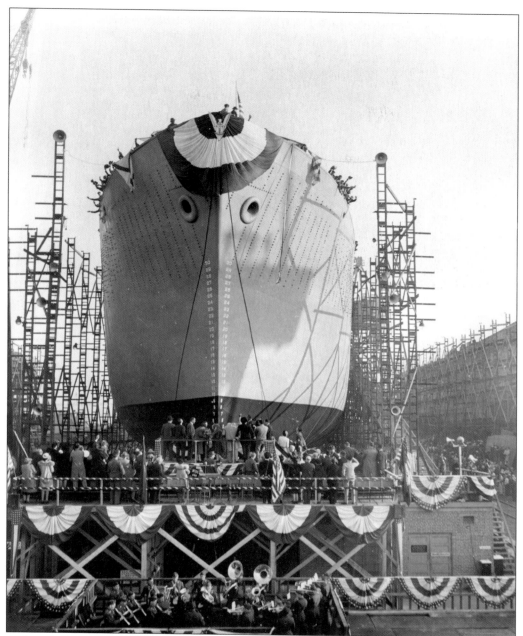

Although Savannah became a ship-building center prior to World War I, its highest production period was during World War II, when the Southeastern Shipbuilding Corporation built 88 Liberty Ships. The first of the Savannah-built, troop-transport vessels was named the USS *James Oglethorpe*, seen here November 20, 1942.

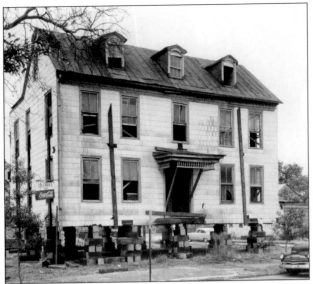

By 1946, when Lady Nancy Astor remarked, "Savannah is a beautiful woman with a dirty face," Savannah's downtown area was marred by neglect and ruin. Once majestic homes were broken into tenement housing or boarded up and abandoned as the city's population moved to the newer, more fashionable suburbs of Ardsley Park and the islands. Thus ignored, the city was laid to waste as one building after another was demolished in the name of progress. By 1956, 13 of the city's 56 major historic landmarks, as identified by the Historic American Building Survey (HABS), had been destroyed.

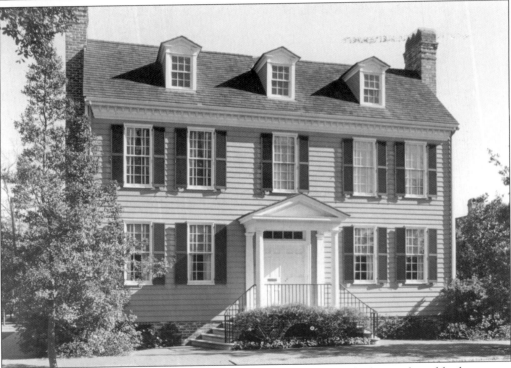

The City Market was razed in 1954 for a parking garage, a fate which was shared by homes on Warren Square. In 1955, the Davenport House was scheduled for demolition to make room for another parking lot, when at the eleventh hour, Anna Colquitt Hunter marshaled a group of seven ladies to purchase the building and save it. This event marked the birth of the Historic Savannah Foundation, which remains a powerful advocate for Savannah's historic preservation efforts. The house, seen above c. 1930, is 24 Habersham, also known as the Mongin House. Below, is the same house after restoration.

Two
BUSINESS AND INDUSTRY

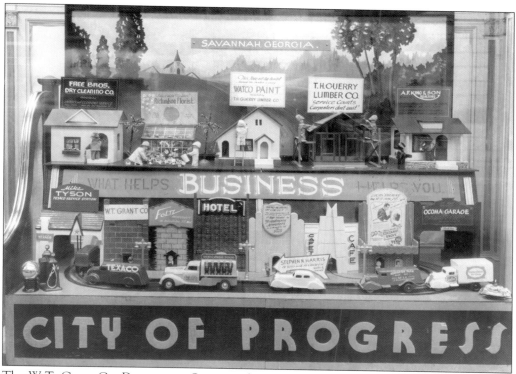

The W.T. Grant Co. Department Store window display is seen here in a 1938 photograph at 5–7 W. Broughton Street. Since its founding in 1733 Savannah has witnessed many evolutions in its economy, beginning with the early agricultural experiments at the Trustees' Garden and ending the 20th century with an historical tourism boom. Between 1997 and 1999, Savannah played host to more than 7 million visitors, who poured more than $2 billion into the local economy. Much of Savannah's tourist economy can be attributed to interest sparked by John Berendt's *Midnight in the Garden of Good and Evil* and the growing interest in historical tourism.

Early scouting reports from South Carolina indicated that Georgia's climate would support the culture of silk. The weather in Savannah was thought to be temperate enough to sustain the mulberry trees on which the silk worms fed. Both the trustees of Georgia and James E. Oglethorpe himself supported this early industry from the time of the founding of the colony. Unfortunately, problems in silk culture husbandry and weather proved insurmountable, and silk culture was largely abandoned by 1774. Construction on the Filature Building on Reynolds Square—seen here in a detail from Fermin Cerveau's "1837 View of Savannah"—began in 1751. The Filature Building served as City Hall from 1789 until 1812. It burned down in 1839.

The Trustees' Garden was the site of the first public agriculture experiments in Georgia. Originally ten acres, the garden was laid out by Oglethorpe within one month of the founding of Georgia. In it was grown a variety of agricultural products including flax, hemp, mulberry trees for silk, indigo, olives, and herbs. The Pirates House, seen here c. 1930, sits on the site of the Trustees' Garden. It was built c. 1794 as a seamen's inn and tavern and was mentioned in Robert Lewis Stevenson's *Treasure Island*. Also on this site in 1762, Fort Oglethorpe (later renamed Fort Wayne) was built; it fell to the British in December 1778.

Henry McAlpin built the Hermitage (begun in 1819) for industrial rather than agricultural pursuits. Notable for the production of Savannah grey brick, the Hermitage is also known as the site of the first railroad in America. In 1820, McAlpin laid the tracks to move a brick kiln from one location to another on his plantation. A century later, automobile pioneer Henry Ford dismantled the house and used the materials to build a new Hermitage in Richmond Hill, 15 miles south of Savannah.

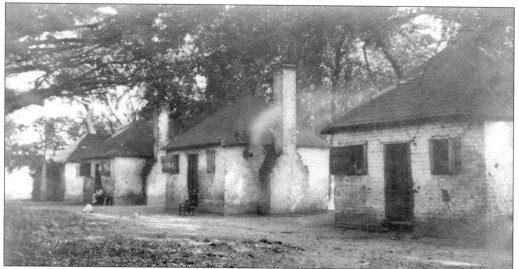

Despite early prohibitions on spirits, slaves, lawyers, and Catholics, all were eventually allowed in Georgia. After jealously observing the prosperity in South Carolina, Georgia legalized slavery in 1751. These slave cabins at the Hermitage provided housing for a fraction of the more than one million slaves in Georgia between 1790 and 1860. This labor force drove the Georgia economy for more than 100 years.

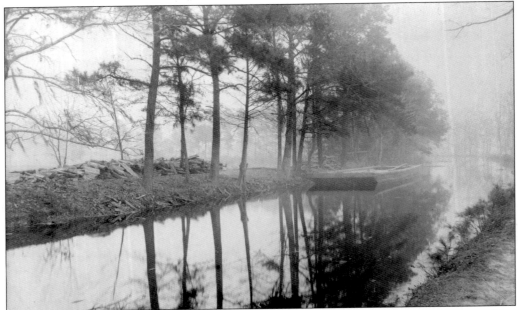

In 1826, work began on a canal to link the Savannah, Ogeechee, and Altamaha rivers. Five years later, construction was completed on the 16.5 mile canal. Later known as the Savannah-Ogeechee Canal, seen here *c.* 1888–1889, this waterway was a vital link between the agricultural fields of Georgia's interior and the commercial portal of Savannah's harbor.

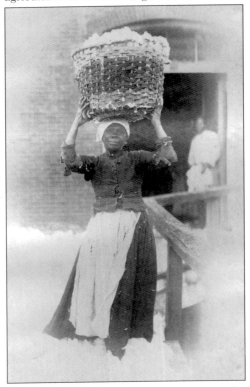

Although not ideal for silk culture, the soil and climate of the Savannah area were better suited for the production of rice and cotton. The woman seen here in a photograph by William E. Wilson, *c.* 1890, may have been a cotton porter on Savannah's docks.

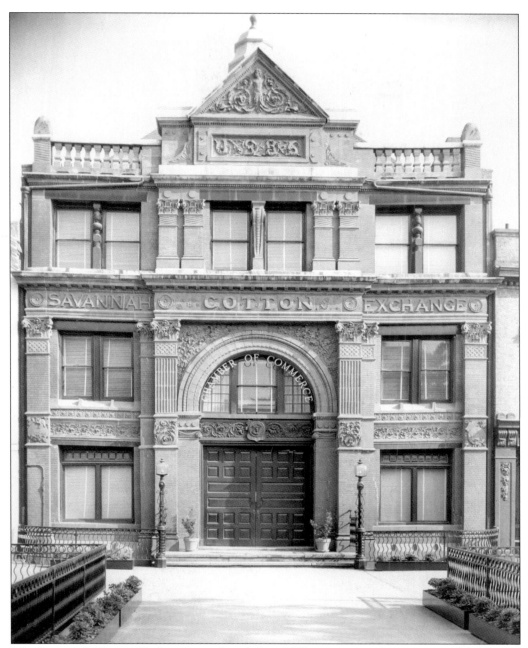

The Savannah Cotton Exchange was founded in 1872 to promote the interests of the cotton industry by providing space to conduct business, mediating disputes, setting standards and rules for classification, and providing current information to its members. The Cotton Exchange building seen here was constructed in 1886 according to the design of William Gibbons Preston. It operated as a merchant's exchange until 1920. It is now occupied by the Solomon's Masonic Lodge Number One.

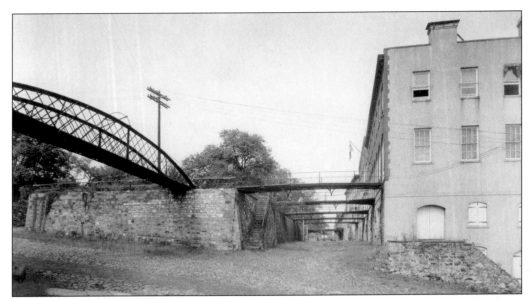

Since the founding of the colony, the Factors' Walk area along Savannah's riverfront has been the site of commercial activity. The entire area, perched high on the bluff above River Street, consists of Factors' Row, the buildings originally used as offices and warehouses for commercial factors and brokers; Factors' Walk, the ballast-paved street running the length of the river between the warehouses and the retaining wall; and the wall itself, which keeps the bluff from washing into the river. The long-abandoned warehouses and offices were replaced primarily with tourist attractions, such as inns and restaurants. This c. 1920 view of Factors' Walk shows the walk (center), Factors' Row (right), and the retaining wall (left).

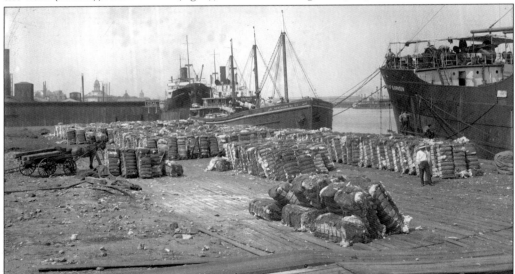

In November 1903, Savannah set a world record for the largest cargo of cotton exported—a British steamship was cleared with a cargo of 26,679 square bales of cotton. Although cotton was a major export for the port of Savannah, other goods shipped from the harbor included lumber and naval stores. By the early 20th century, Savannah became both an export and import center. The image dates from c. 1920.

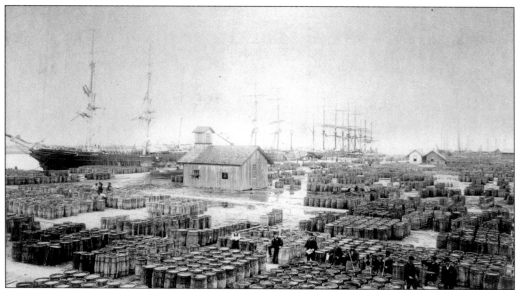

The naval stores industry began in 1870, and by 1883 Savannah had become "the largest naval stores market in the world." "Naval stores" is a generic term referring to the products such as turpentine, pitch, and rosin that are derived from coniferous trees. Originally naval stores were used primarily in the wooden ship building industry, which substantially abated in the early 20th century. This view of naval stores on the river front was taken c. 1885.

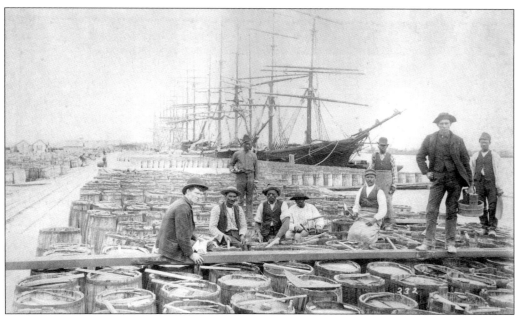

Charles Herty revolutionized the turpentine industry by inventing the Herty Cup, a less intrusive, more efficient way of collecting sap necessary for the production of naval stores. Herty's passion for pine led him from naval stores to pulp and paper-making. In 1931, he opened an experimental laboratory in Savannah, which attracted Union Bag and Paper Company to the area.

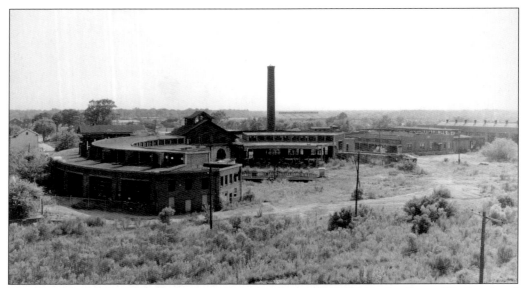

The Central of Georgia Railway was chartered in December 1833, as the Central Railroad and Canal Company. William Washington Gordon served as its first president until his death in 1842. The Central of Georgia Railway was instrumental in the development of Georgia's interior. The roundhouse complex, shown here, was built during the 1850s on W. Harris Street, off Martin Luther King Jr. Boulevard, formerly W. Broad Street.

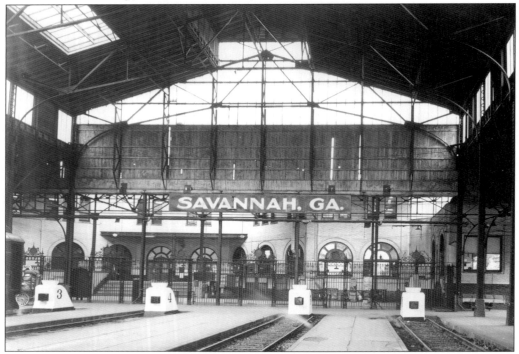

Savannah was a terminus point for the Seaboard Air Line Railway. Union Station, seen here *c.* 1940, was built on Martin Luther King Jr. Boulevard in 1899. It was demolished in 1963 to make way for the construction of Interstate 16 into the city.

The City Market was built between 1870 and 1872 on the site designated by the Colonial Assembly for a public market. The City Market served as Savannah's farmers' market until 1954, when it was demolished to make way for the parking garage on Ellis Square at the intersection of Barnard and St. Julian Streets. This *c.* 1888 stereograph view captures the activity surrounding the market area.

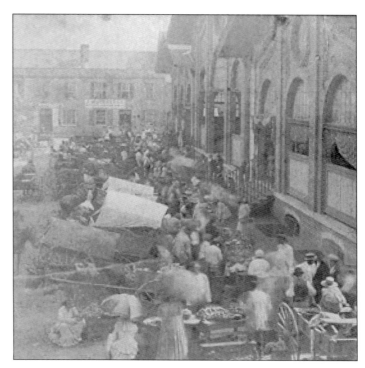

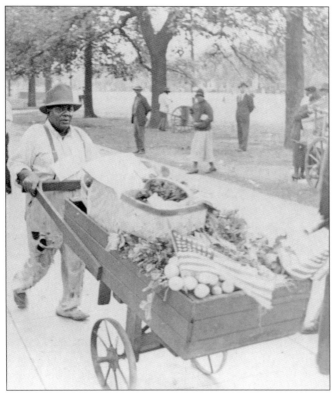

Pictured is Shorty George, "Star of the Hucksters," in the Annual Hucksters Contest, *c.* 1955. "Huckster" is another name for a street vendor.

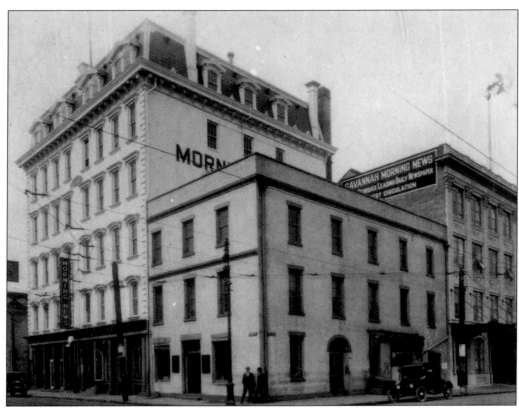

The *Savannah Morning News* buildings on the corner of Bay and Whitaker Streets are seen here in 1930. The *Savannah Morning News* was first published in 1850, and was the first daily in Georgia to use a folding machine and automatic mailer for affixing addresses to subscribers' newspapers. In 1931, the *Savannah Morning News* bought the *Savannah Evening Press*, which had first published in 1891. The *Savannah Morning News* remains the main newspaper in the city.

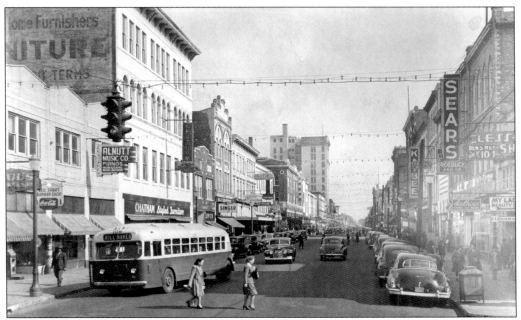

From the 1920s through the 1950s, Broughton Street served as the primary business district for Savannah. In recent years, Broughton Street has undergone a major revitalization project, which has meant the return of many businesses to downtown. This view of Broughton Street looking east from Jefferson Street, dates from about 1950.

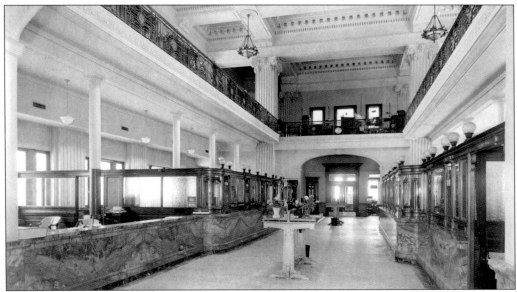

Remer Y. Lane founded the Merchant's Bank in Valdosta in 1888. His son Mills B. Lane became vice president of the Savannah-based Citizens Bank, which later merged with the Southern National Bank to become the Citizens and Southern Bank. Seen here is the interior of the Citizens and Southern Bank on Johnson Square in Savannah, c. 1940. This neo-classical building, designed by architects Mowbray and Uffinger of New York, was commissioned by Mills B. Lane in 1907.

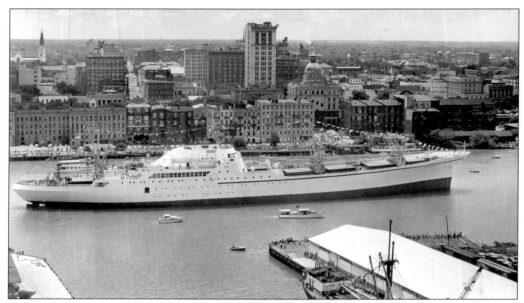

This view of Savannah's riverfront from Hutchinson Island includes the NS (nuclear ship) *Savannah*, named in honor of the SS (steamship) *Savannah*. The NS *Savannah* made her maiden voyage from Savannah's port in August 1962. The riverfront is made up of factors wharves and warehouses turned tourist attractions, such as restaurants, inns, and gift shops.

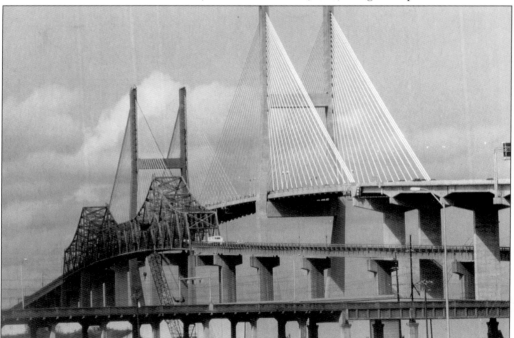

This 1991 photograph shows both the old and new Talmadge bridges that link Savannah with South Carolina. The old bridge, in the foreground, was dedicated October 15, 1954, at which time it was the largest bridge in Georgia. The old bridge opened Hutchinson Island to vehicular traffic for the first time. The new bridge opened for traffic on March 26, 1991.

Three

RELIGION
AND EDUCATION

Education and religion are two facets of Savannah's history that have been bound together since the founding of the colony. An example of this interdependence is Bethesda Home for Boys, seen here *c.* 1920–1930, which served the spiritual and educational needs of the colony's orphans. "Bethesda" means "House of Mercy." Bethesda Home for Boys, previously known as Bethesda Orphanage, is located 15 miles south of Savannah on its original site.

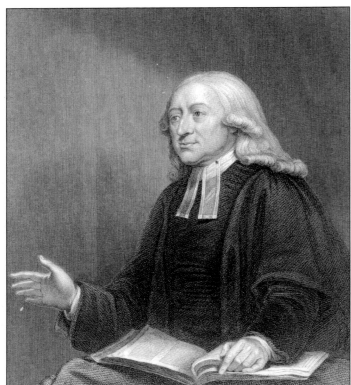

John Wesley arrived in Savannah in 1736 to take the pulpit as the rector of Christ Church. John Wesley founded Methodism, established the first Sunday School in America, and published the first English hymnal in America. However, Wesley's tenure in Georgia was marred by a scandal. When Wesley dawdled in pursuing a relationship with Sophie Hopkey, she married another man. A disappointed Wesley refused communion to the new Mrs. William Williamson whose husband then charged Wesley with public defamation of character. Soon after the charges were brought against him, Wesley returned to England.

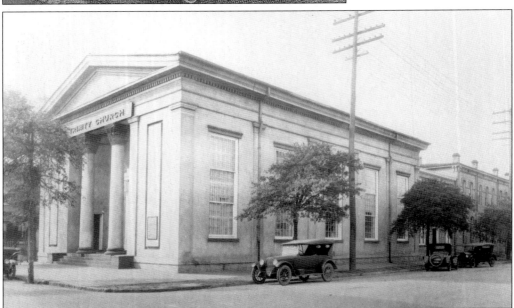

The present Trinity United Methodist Church building, located on Telfair Square, is a successor to the oldest Methodist congregation in Savannah. Construction on the current building, seen here *c.* 1925, began in 1848. John B. Hogg designed this Greek revival-style church that is built of Savannah grey brick with a stucco veneer.

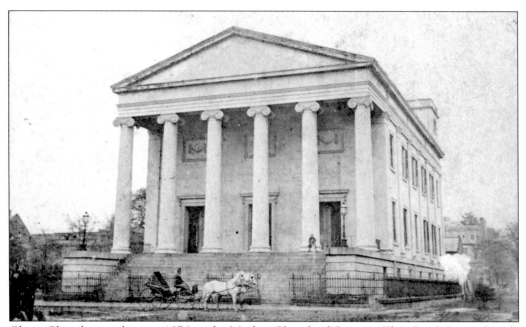

Christ Church, seen here in 1876, is the Mother Church of Georgia. This Greek Revival–style building, completed in 1840, is located on the original site of the church. Hanging in the northeast tower is a bell forged in 1819 by Revere and Sons of Boston.

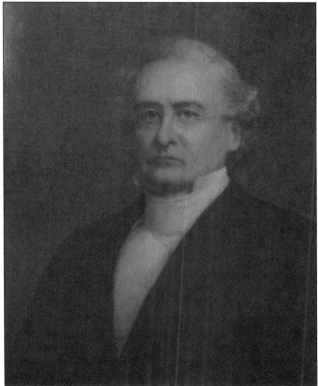

Stephen Elliott was consecrated the first bishop of the Episcopal Diocese of Georgia in 1841 at Christ Church, Savannah. Elliott was born in 1806 in Beaufort, South Carolina, and died in 1866. He studied law with James L. Pettrigru, a prominent lawyer and founder of the South Carolina Historical Society. Elliott himself was a founding member of the Georgia Historical Society. He was also instrumental in founding the University of the South at Sewanee, Tennessee.

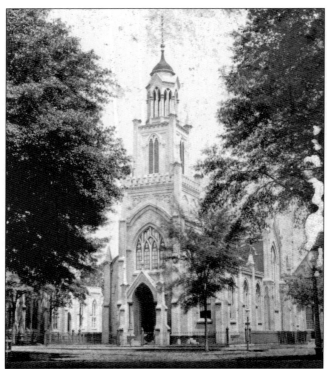

In 1733, the *William and Sarah* brought the first Jewish settlers to the colony of Georgia. Shortly after their arrival, the Jews established a house of worship known as K.K. Mickve Israel. Mickve Israel is the third-oldest Jewish congregation in the United States. The present temple, completed in 1878, sits on Monterey Square.

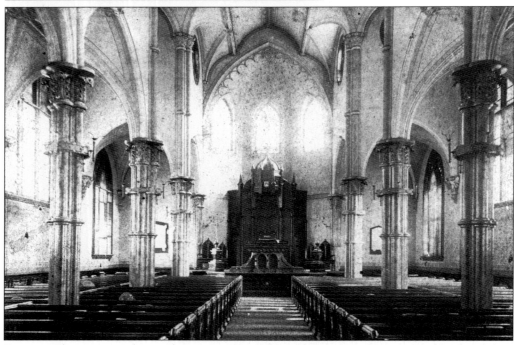

Due to its location on the southeast trust lot of Monterey Square, Temple Mickve Israel does not conform to the square floor plan of traditional synagogues. This is the only Gothic-style Jewish temple in America.

Scottish Presbyterians were present at the founding of the colony and by 1755 had built their first church. The present Independent Presbyterian Church stands on the site of the third church building, at the corner of Bull and Liberty Streets. Lowell Mason, the hymn writer who authored "Nearer My God to Thee," was church organist in the 1820s. In 1885, Woodrow Wilson married Ellen Axson, granddaughter of Independent Presbyterian Pastor I.S.K. Axson, here.

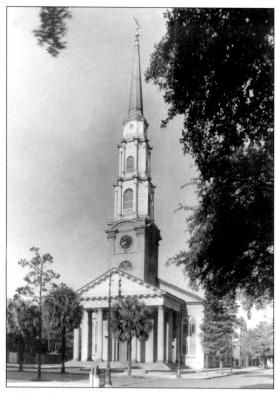

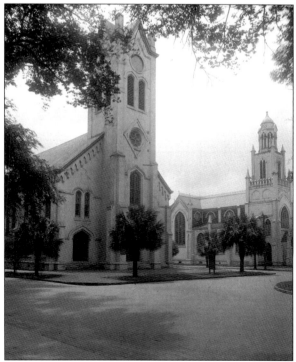

Shown is a view of First Presbyterian Church (left) and Temple Mickve Israel on Monterey Square, c. 1920. In 1827, members of Independent Presbyterian Church petitioned the Presbytery of Georgia to organize a new church. This building, constructed between 1856 and 1872, was the third location for the church. The church moved to its new location at Washington and Atlantic Avenues in 1935. In 1941, the Monterey Square site was acquired by Armstrong College for use as a science building. The church building has been demolished.

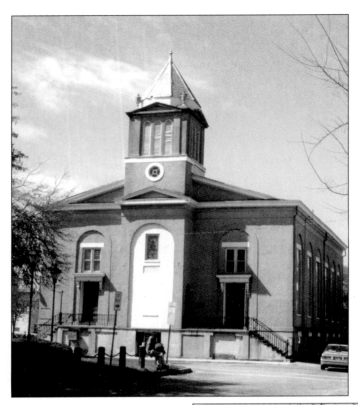

Organized in 1788, the First African Baptist Church was the first African-American congregation in North America. Andrew Bryan, who served as pastor from 1788 to his death in 1812, was ordained as a minister while still a slave at Brampton Plantation. The congregation of First African Baptist bought the northwest trust lot on Franklin Square in 1832. The current building, erected in 1859, was designed to resemble an English church. (Photograph taken February 2001.)

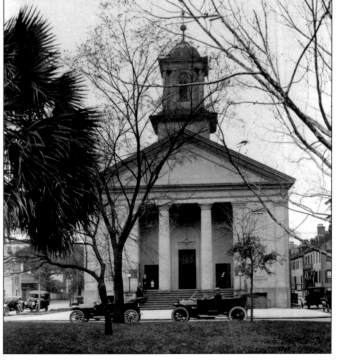

First Baptist Church on Chippewa Square claims to be the oldest original church building in Savannah. The congregation was organized in November 1800. In 1830, Elias Carter provided plans for the Greek Revival church, with the cornerstone laid in 1831. Two years later, the church was dedicated. This photograph was taken prior to 1922, when the church was renovated by Henrik Wallin.

The Catholic Church in Savannah was established in 1796, and in 1850 the Diocese of Savannah was created. Construction on the Cathedral of St. John the Baptist began in 1873 on its current site; the building was dedicated in 1876. The cathedral was nearly destroyed by fire in 1896 and was rebuilt in 1899. In December 2000, the cathedral was rededicated after nearly three years of restoration work.

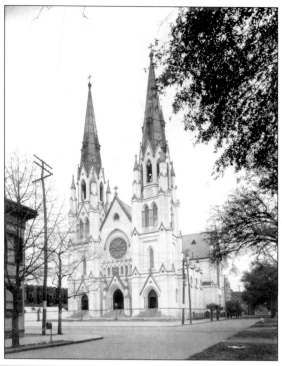

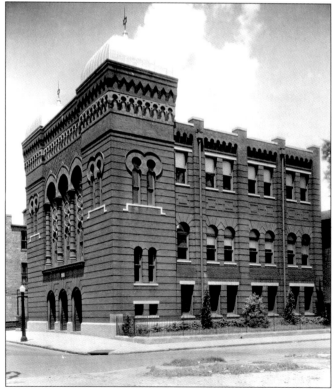

The building seen here, c. 1934, sits on Montgomery Street opposite the new county courthouse complex. It was built c. 1909 according to the design of Hyman W. Witcover for the Congregation B'nai B'rith Jacob. The congregation was established in the late 19th century in the Ashkenazic (German) tradition, different from the Sephardic (Spanish-Portuguese) tradition of Mickve Israel. As the congregation grew, it moved to a larger, newer building on Savannah's south side. The building was purchased in 1969 by St. Andrew's Independent Episcopal Church, who held its first services here in February 1970.

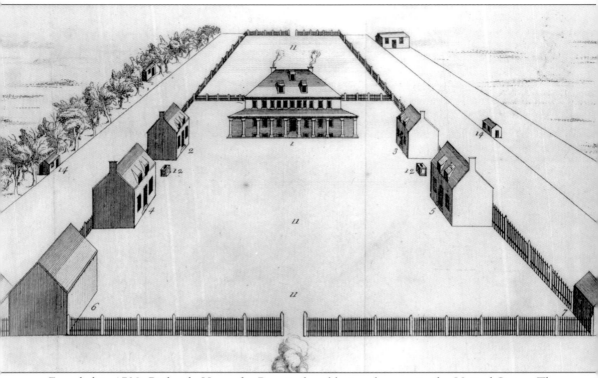

Founded in 1739, Bethesda Home for Boys is the oldest orphanage in the United States. The first cornerstone was placed in 1740, and orphans occupied the buildings later that same year. In 1805, fire ravaged the compound, forcing its closure. In 1855, the Union Society became trustees of Bethesda and also began construction on the current building, which has been in continuous use since 1867. The image seen here is the original plan for Bethesda.

Rev. George Whitefield arrived in Savannah in 1738 with James Habersham to establish Bethesda Orphanage. For the next 30 years, Whitefield campaigned tirelessly for funds to support the home. He is reported to have preached 18,000 sermons and made 13 transatlantic trips.

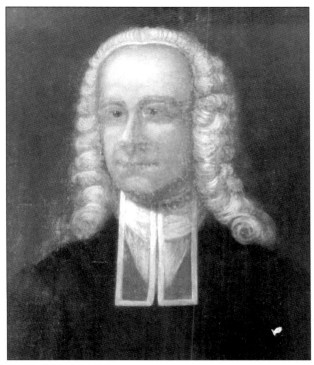

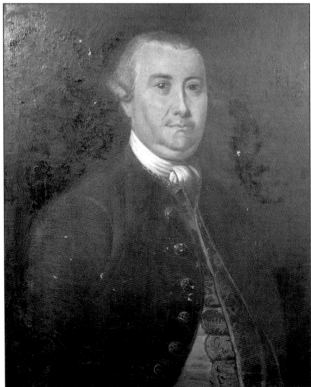

In addition to establishing Bethesda Orphanage, James Habersham also served as its administrator and educator. After stepping down from those positions in 1744, Habersham became a merchant. He exported the first cotton to be shipped from America in 1764. When Royal Governor James Wright left Savannah in 1771, Habersham served as acting governor until Wright's return.

49

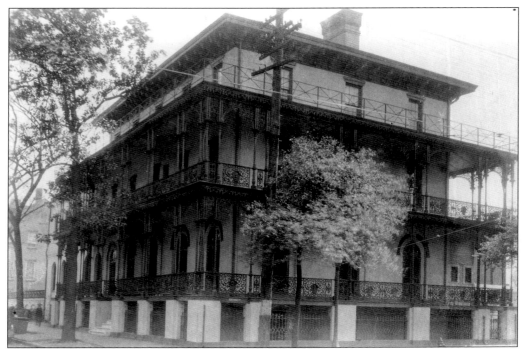

From 1738 to 1801 Bethesda accepted both boys and girls to its care. Starting in 1801, girls were no longer admitted, but were sent to the newly established Savannah Female Orphan Asylum. Later, the Augustus Wetter House, seen here in 1934, served as the home for the girls, until the 1950s. The Wetter House was on the corner of Martin Luther King Jr. Boulevard, formerly W. Broad Street, and Oglethorpe Street. It was demolished in 1950.

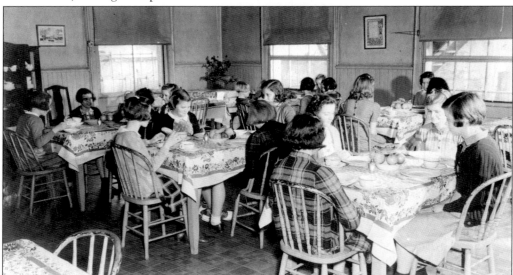

The Savannah Home for Girls, as it was later known, was chartered to "educate, clothe, and support poor and destitute female children as orphans or whose parents were unable to support them." In 1972, the activities of the home were absorbed into the Parent and Child Development Services of Chatham County.

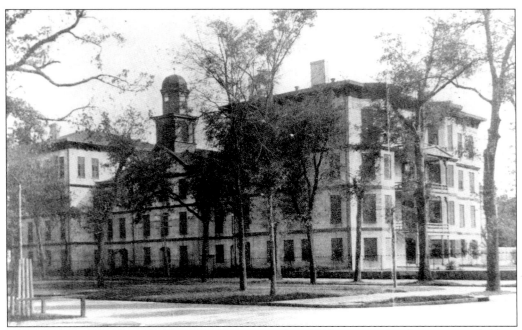

Chartered in 1788, the Chatham Academy opened in 1813 to provide education to children from first grade through high school. The Chatham Academy building on the corner of Bull and Oglethorpe Streets, seen here *c.* 1890, burned in 1899.

Built on the site of the old Chatham Academy building after the 1899 fire, the "new" Chatham Academy now serves as the headquarters of the Chatham County Board of Education.

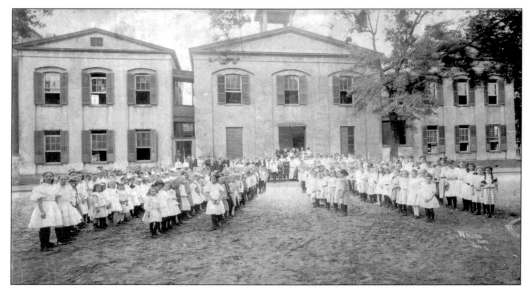

Located on Calhoun Square, Massie School was built in 1856 to educate Savannah's poor. It was the first public school in the city. The school was used as a hospital by Union troops occupying Savannah during the Civil War. Massie continued to operate as a public school until 1974. It now serves as a heritage-education site.

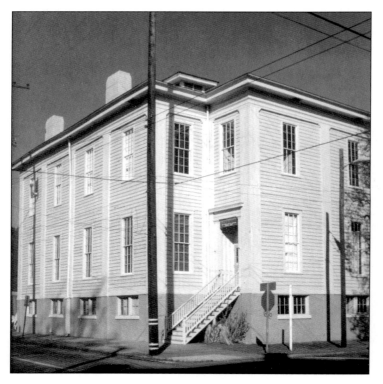

Located on the corner of Price and E. Harris Streets, the Beach Institute was built in 1867 with funding from the American Missionary Association to serve as a school for Savannah's African-American children. In 1919, the school closed for lack of enrollment due to competition from Savannah's first black public high school and the Georgia State Industrial College, now called Savannah State University. (Photograph taken February 2001.)

The Pape School educated Savannah's children from 1900 until 1955. Located at the southeast corner of Drayton and Bolton Streets, the Victorian-style house was built in 1881 and demolished in the late 1950s. The Pape School participated in the progressive-education movement which integrated free play and physical education into a more traditional curriculum. The Pape School is notable as the site of the first Parent-Teacher Association in Georgia, formed in 1909.

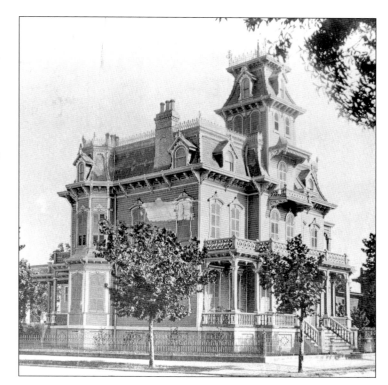

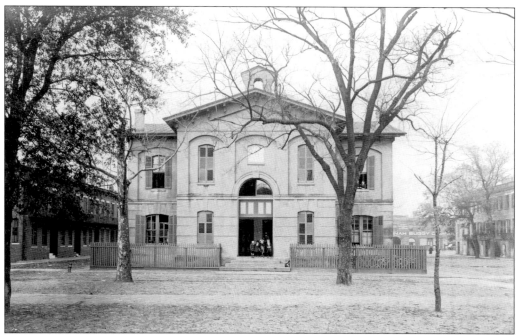

St. Patrick's School, seen here c. 1890, was located on the trust lot where the current county jail now stands on Montgomery and W. York Streets. St. Patrick's is one of many public, private, and parochial schools that have educated Savannah's children through the decades.

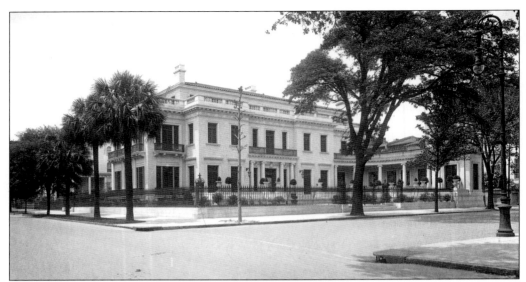

The Armstrong House, seen here *c.* 1920, was built at the corner of Bull and Gaston Streets between 1916 and 1919 for George F. Armstrong by the design of Henrik Wallin. In 1935, the City of Savannah acquired the house for Armstrong College, which later became Armstrong Atlantic State University, whose campus moved to the southside of Savannah in 1966.

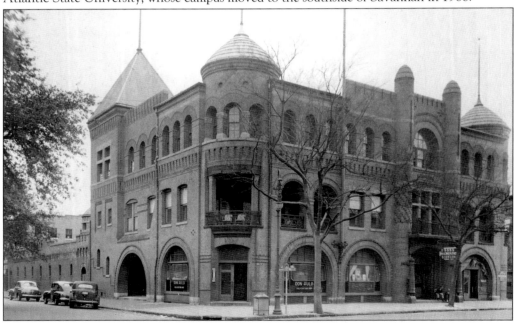

Founded in 1975 by Paula and Richard Rowan and May and Paul Poetter, the Savannah College of Art and Design has rapidly established itself in Savannah. One of SCAD's lasting contributions to the city has been the adaptive reuse of many of Savannah's neglected, larger buildings, especially neighborhood elementary schools. The first building SCAD purchased was the Savannah Volunteer Guards Armory, seen here about 1940. SCAD renamed it Preston Hall in honor of the architect William Gibbons Preston, who built the Armory in 1893 on Madison Square.

Four

DISASTERS

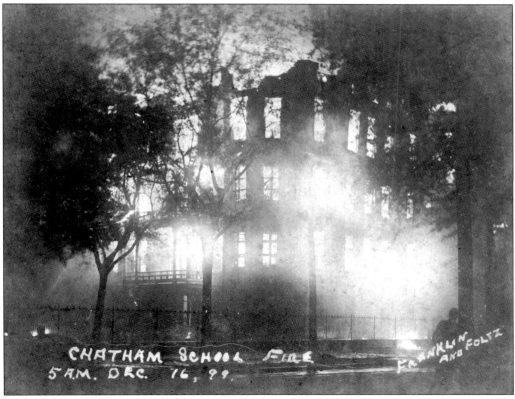

Savannah's charm has been threatened over the years by a series of devastating fires, outbreaks of virulent pestilence, and volatile weather patterns, ranging from hurricanes to ice storms. Yet, in the face of these tribulations, Savannah has survived and rebuilt. Seen here is the Chatham Academy fire, at 5 a.m. on December 16, 1899.

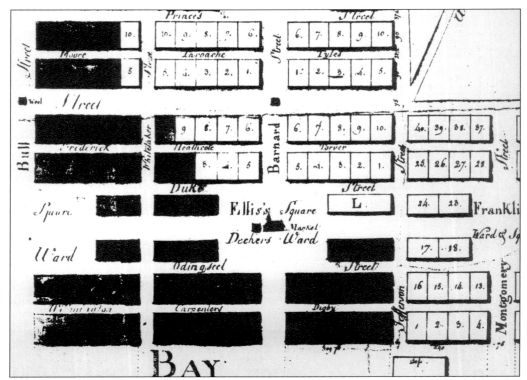

In the winter of 1796, the first major fire to tear through Savannah started in Ellis Square when a stove tipped over. The ensuing blaze destroyed approximately 300 buildings from Bay Street to Oglethorpe Avenue (then S. Broad Street), and from Barnard to Abercorn Streets.

"Alas! never did the sun set on a gloomier day for Savannah, or on so many aching hearts" (quoted from *Georgian,* January 1820.) The fire of January 1820 began in Franklin Square, allegedly in the livery of Mrs. Platt's boarding house, a block from where the 1796 fire started. The 1820 fire destroyed most of the buildings north of Broughton Street to the river. At the time, losses were estimated at $4 million.

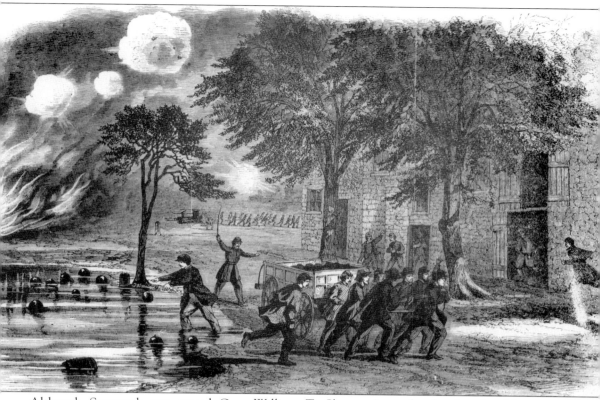

Although Savannah was spared Gen. William T. Sherman's torch, shortly after Union occupation of the city in December 1864, fire erupted from an ammunition depot at Granite Hall on the corner of Broughton Street and Martin Luther King Jr. Boulevard, formerly W. Broad Street. Thanks to the firefighting efforts of Federal troops, only 100 buildings were lost.

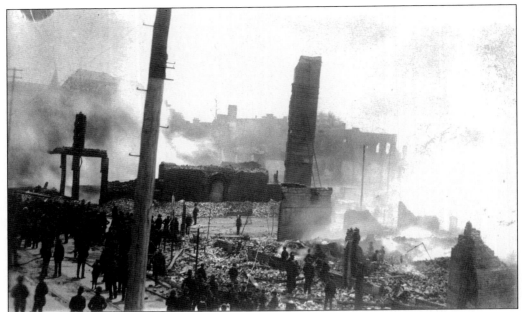

On the night of April 6, 1889, Savannah's last great fire started in the show window of Hogan's Dry Goods, at 163 Broughton Street, on the corner of Barnard Street. A gas light ignited display materials and quickly spread to the roof from which it leapt to neighboring buildings. The ruins of Hogan's smolder in this morning-after picture.

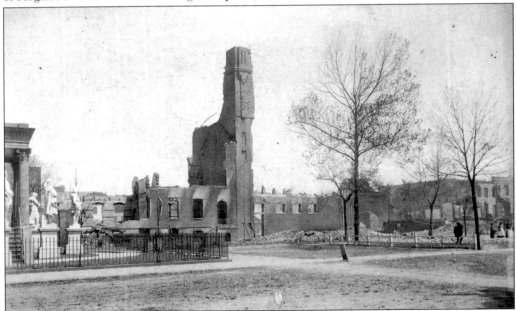

The fire proceeded from Hogan's to Telfair Square where it quickly consumed the Odd Fellow's Hall on the northwest corner of the square. The Telfair Museum of Art was spared by constant streams of water from hoses trained on the exterior walls, which were blistered by the heat. This image shows the ruins of the Odd Fellow's Hall in the center with the Telfair Museum of Art to the left.

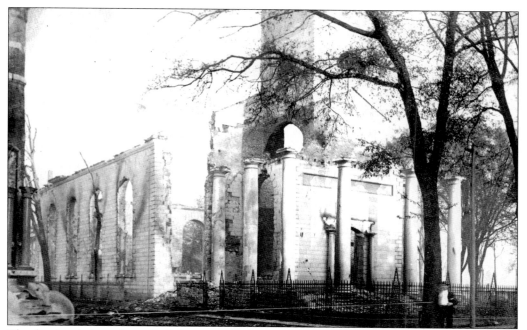

The fire headed south on Bull Street to the Independent Presbyterian Church, whose steeple was showered with cinders and sparks. Although the roof was fireproof, the wooden steeple toppled, allowing the flames to consume the entire building.

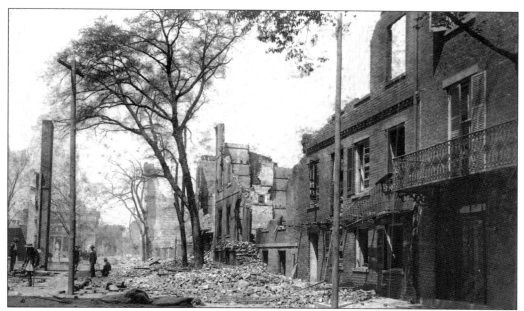

The severity of the conflagration was such that the mayor of Savannah telegraphed Charleston, Atlanta, Macon, Augusta, and Jacksonville for reinforcement. However, by the following morning, the fire was under control. In all, more than 50 buildings were destroyed with losses estimated at $1.25 million. This view of State Street looking west from Whitaker shows the heart of the destruction.

As a precaution against fire, a city ordinance required "under penalty, the sweeping of chimneys once a month." The chimney sweeps seen here c. 1880 brandish the tools of their trade: brushes and scrapers.

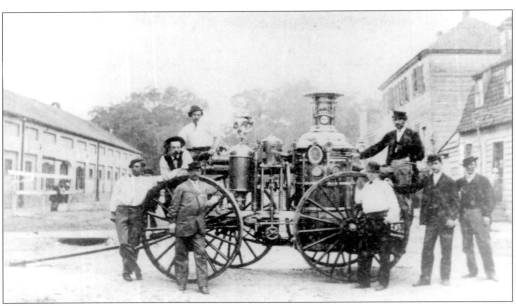

Savannah was the first city in the United States to have a paid fire department. The Savannah Fire Company was organized in 1820, but became a permanent paid company after the 1876 fire. Seen here is a fire truck c. 1890.

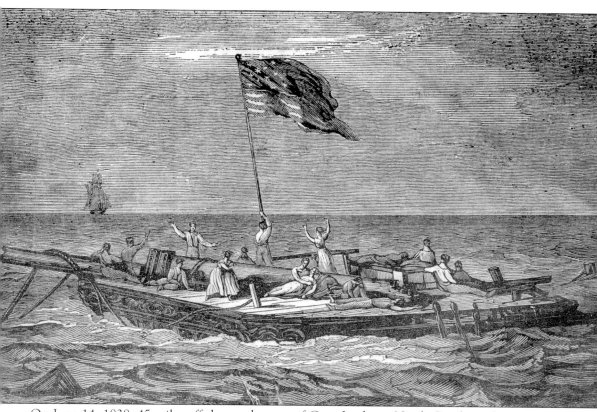

On June 14, 1838, 45 miles off the south coast of Cape Lookout, North Carolina, the steam packet *Pulaski*, carrying more than 150 passengers and crew, sank after a boiler explosion ripped the ship in two. "Our city has sustained a loss which years cannot efface," reported the *Georgian*, when word reached the city nearly a week after the tragedy. Approximately 95 Savannahians, mostly women and children headed for northern retreats, had boarded the *Pulaski* bound for Baltimore with a stop in Charleston. The total number of lives lost is inexact; however, Savannah lost many friends and family members in the wreck—one family lost 8 of 10 members. This line drawing depicts the "distressing condition of the survivors on the wreck, when fallen in with by Capt. Davis, of the schooner *Henry Camerdon*."

The first major epidemic of yellow fever in 1820 added to Savannah's losses for that year. First appearing in August, the fever claimed the lives of nearly 700 Savannahians. Physicians of the day had no understanding of causes or cures for this disease, whose early symptoms included chills progressing to high fever, back pains, urinary discomfort, and jaundice. A gruesome death followed within a week's time marked by hemorrhaging, vomiting, delirium, convulsions, and often coma. (*Frank Leslie's Illustrated Newspaper*, September 1873.)

NAMES OF THE DEAD,

BEING A RECORD OF

THE MORTALITY IN SAVANNAH,

DURING THE EPIDEMIC OF 1854,

WITH A LIST OF

THE DONATIONS IN AID OF THE SICK,

ALSO A BRIEF ACCOUNT

OF THE SEPTEMBER GALE,

More yellow fever deaths came in the epidemic of 1854, which claimed the lives of more than 1,000 people. From August to September, many residents fled the city and businesses closed. The Savannah Benevolent Association was organized to provide relief to the families of fever victims. By providing food, medicine, nurses, and coffins, the SBA supplemented the efforts of the city, which was overwhelmed by the plague.

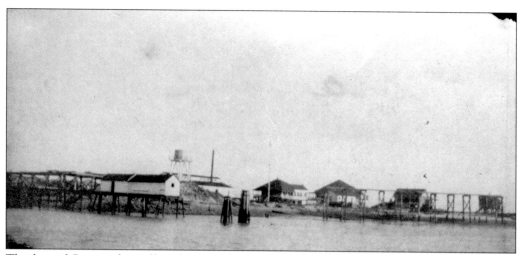

The last of Savannah's yellow fever epidemics arrived in August 1876. Quarantine stations, such as the one seen here in 1907, were safety measures used to protect the harbor city from imported diseases. Doctors at the time thought yellow fever was borne by human contagion; later they discovered that the responsibility for the disease rested with the common mosquito.

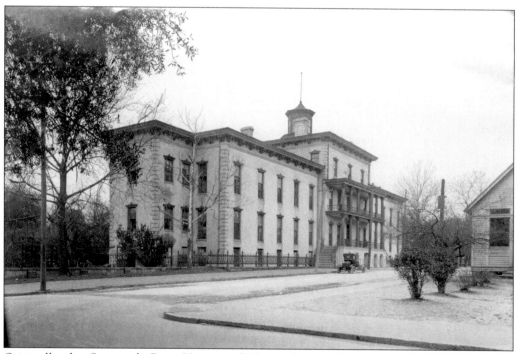

Originally the Savannah Poor House and Hospital, the old Candler Hospital sits on E. Huntingdon Street between Drayton and Abercorn Streets. Beneath the parking lot of the hospital is a tunnel system which may have been either the hospital morgue or a vault for the storage of fever victims.

Savannah was besieged by at least three major hurricanes between 1893 and 1906 alone. The hurricane of 1898 brought flood waters to Savannah.

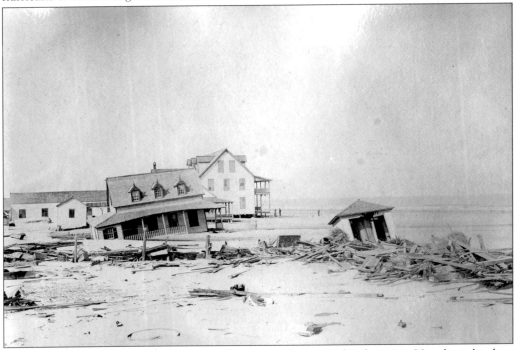

Savannah was usually spared the worst of hurricanes because of its location 20 miles inland on a 40-foot bluff. Tybee Island was rarely so lucky, often receiving the brunt of the storms. The image above shows the devastation on Tybee Island after the Hurricane of 1906.

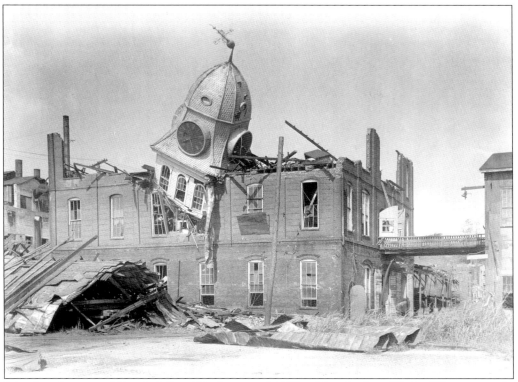

John Rourke opened Rourke's Iron Works around 1871 as Novelty Iron Works. The iron works was in business for more than 60 years when it was destroyed by the hurricane of 1942. Rourke's Iron Works was located on the east side of Savannah near the Trustees' Garden.

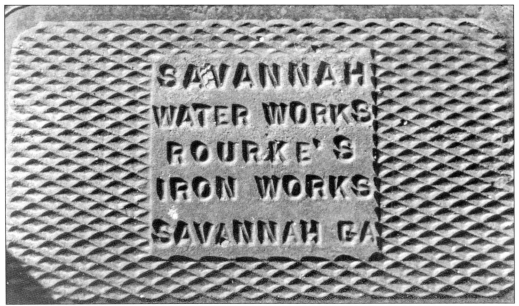

On June 30, 1933, the U.S. Department of Agriculture weather kiosk in Wright Square was removed from service, despite the pleas of Savannahians, including Mayor Wallace J. Pierpont, who claimed that it "was consulted by between 20 and 50 people hourly 12 hours during the day." Savannah was among the 57 original weather stations established in the United States in 1871.

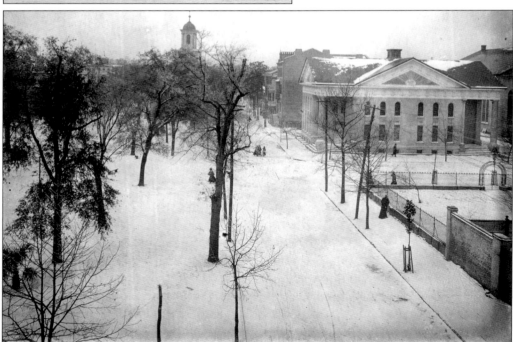

Although infrequent, ice and snow storms are beautiful and devastating visitors to Savannah. This image shows Chippewa Square in the storm of 1893 or 1895.

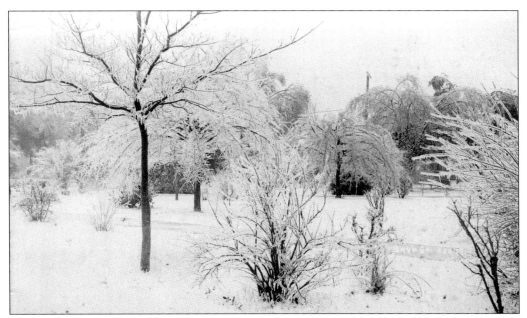

Two notable storms occurred in 1914 and 1922. Snow turned to ice on February 26, 1914, and "transformed the city into a fairyland of crystal."

The ice storm of 1922 was made worse by the fact that the trees had not yet recovered from the 1914 storm. The ice snapped power lines and trees. "Pedestrians had to dash from one corner to another to escape crashing branches and in many cases took to the middle of the streets." (Quoted from *Savannah Morning News*, January 27, 1922.)

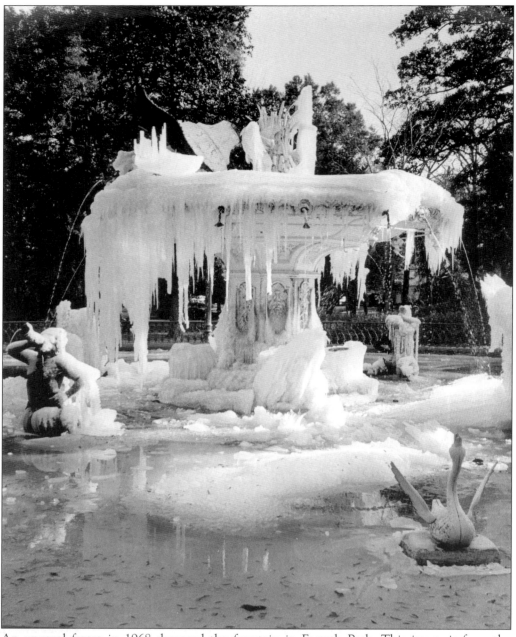

An unusual freeze in 1968 damaged the fountain in Forsyth Park. This image is from the *Savannah Morning News*.

Five

PARKS AND SQUARES

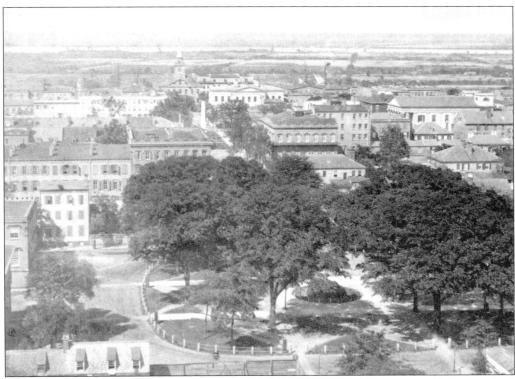

The squares of Savannah are what set her apart from other cities. A visitor in 1842 remarked, "The squares already alluded to, certainly contribute much to the beauty and agreeableness of the city. They are green spots in its vast sand bed, which strike the eye with pleasure." Of the original 24 squares in the Historic District, 22 remain. The image seen here is a view of Wright Square, *c.* 1880–1885.

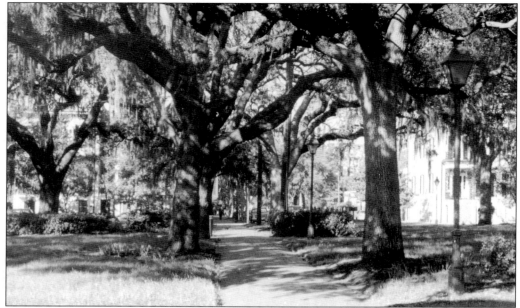

Calhoun Square was laid out in 1851 and named for states' rights advocate John C. Calhoun of South Carolina. Calhoun served as senator, secretary of war under James Monroe, and vice president under John Quincy Adams and Andrew Jackson. Calhoun Square is the site of the Massie School and Wesley Monumental Methodist Church. (Photograph taken February 2001.)

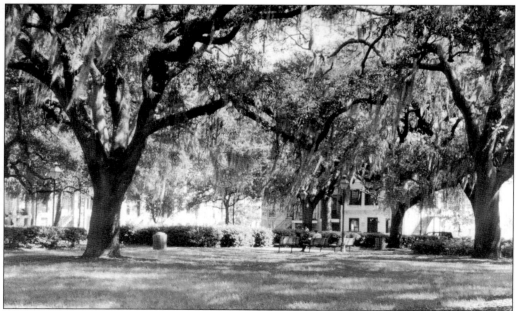

Named for William Pitt, Earl of Chatham, Chatham Square was laid out in 1847. William Pitt supported the colonists against the crown on the issue of rights and representation. Chatham County, in which Savannah is located, is also named for Pitt. (Photograph taken February 2001.)

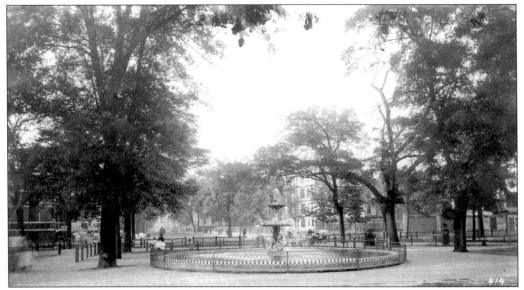

Photographed here *c.* 1889 by William E. Wilson, Chippewa Square was laid out in 1815 and named for a battle in the War of 1812. The fountain seen here was donated to the square by members of the First Baptist and First Presbyterian Churches, both of which are located on the square. The James E. Oglethorpe Monument, designed by Daniel Chester French, replaced the fountain in 1910.

This 1930s view of Chippewa Square shows the First Baptist Church (right) and the Eastman-Stoddard-Hull-Barrow House. Chatham Academy has a presence on the square as does the Savannah Theater. More recently, the square was the site of the "bench scenes" in the movie *Forrest Gump.* That bench was a movie prop, now located in the Savannah History Museum.

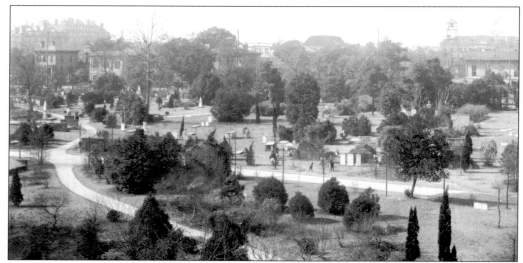

Originally the burial ground for Christ Church Parish, Colonial Park Cemetery, seen here c. 1920–1925, was the city's third cemetery and was used from 1789 until it closed in 1853. After Bonaventure and Laurel Grove cemeteries opened, many families had relatives' remains removed to these new locations. In 1895, the city restored the cemetery and made it a public park.

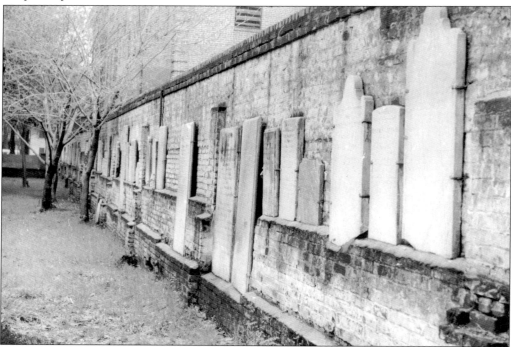

The east wall of the Colonial Park Cemetery is faced with stones and markers which were damaged or broken from years of neglect and abuse. James Habersham, Button Gwinnett, Samuel Elbert, and Archibald Bulloch are a few of the more notable historical figures whose remains rest in Colonial Park Cemetery. Also of note in the park is the marker to the burial spot of victims of the 1820 yellow fever epidemic, which claimed more than 700 lives.

Named for "Columbia," the female personification of the United States, Columbia Square was laid out in 1799. The Davenport House sits on the northwest corner of the square. The fountain at its center was brought from Wormsloe Plantation in 1970 and is dedicated to Augusta and Wymberley DeRenne, descendants of Noble Jones, founder of Wormsloe. (Photograph taken February 2001.)

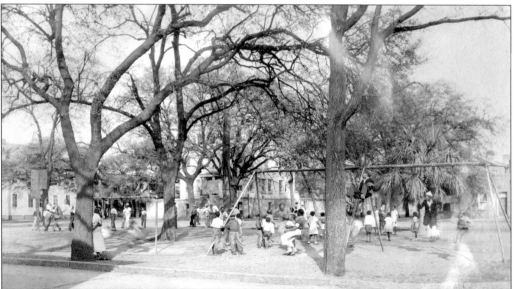

Crawford Square was laid out in 1841, seven years after the death of its namesake, William H. Crawford. Crawford served as minister to France and James Madison's secretary of the treasury. He may be remembered best for his failed presidential bid, which found him in a four-way race with John Quincy Adams, Henry Clay, and Andrew Jackson. When no candidate received a majority vote, the House of Representatives chose Adams as president. Crawford served as circuit-court judge in Georgia until his death in 1834. Crawford Square, seen here c. 1941, serves as a neighborhood playground.

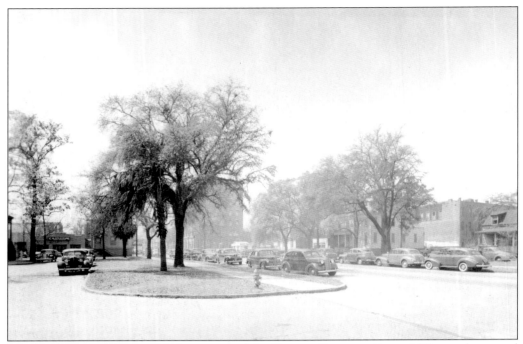

Elbert Square, seen here c. 1940, was named for Georgia Governor Samuel Elbert, who served from 1785 to 1786. Laid out in 1801 after the 1796 fire, the city sold its lots to finance a city-wide cistern project. The construction of the Savannah Civic Center and the infringement of city streets whittled away at the square, of which very little remains.

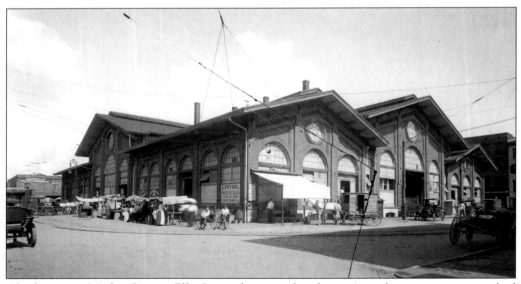

Also known as Market Square, Ellis Square has served as the city's market area since it was laid out in 1734. The square was later named for Royal Governor Henry Ellis. In 1820, fire destroyed the marketplace, which had been built with tax money raised in 1788. The market was rebuilt, but was demolished in 1954 to make way for the parking garage that stands on the site today.

Emmet Park, located on E. Bay Street, was named for Irish patriot Robert Emmet. The Harbor Light, seen here about 1900, was erected in 1858 by the U.S. government. The light guided ships into the harbor around ships scuttled by the British during the Revolutionary War.

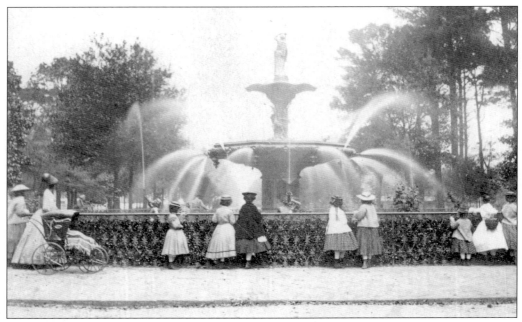

Originally set aside by William B. Hodgson prior to 1851 for "the pleasure of the public," Forsyth Park was named for John Forsyth, governor and secretary of state to Presidents Andrew Jackson and Martin van Buren. Over the years, the park was expanded to its current 30 acres.

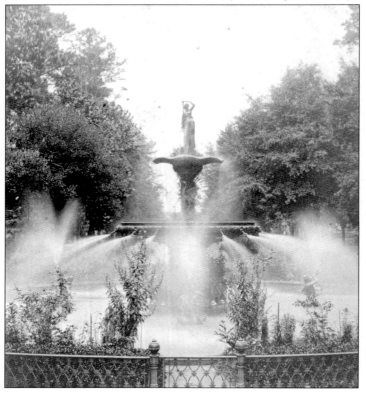

Forsyth Park's jewel is the 1858 cast-iron fountain. At the time of its unveiling, the fountain was thought to be the largest in the United States. Similar fountains are in Cuzco, Peru, and Poughkeepsie, New York; all three fountains are reminiscent of the fountain in Paris's Place de la Concorde.

Erected in 1874, the Confederate Monument, seen here *c.* 1910, was sponsored by the Ladies Memorial Association according to the design of Robert Reid. The monument was made in Canada and transported by ship in order that the memorial to Confederate dead never touch Yankee soil.

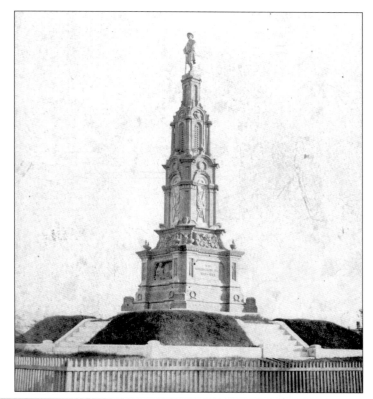

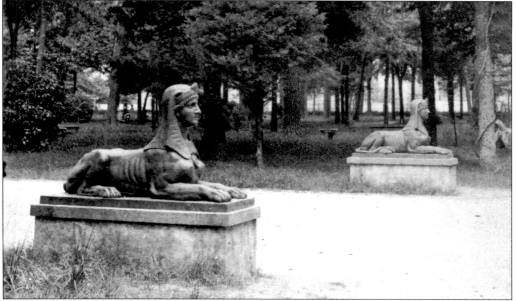

The Bull Street entrance to Forsyth Park is no longer guarded by these two stone sphinxes. In the 1900s, mischievous boys blew up the sphinxes with firecrackers. Another notable feature of the park is its two dummy forts, one of which houses a fragrant garden for the blind, and the other of which serves as storage for the city.

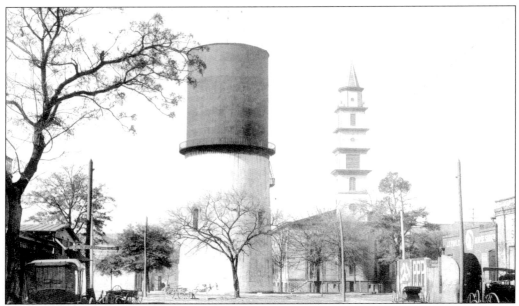

Dedicated in 1791, Franklin Square was named for Benjamin Franklin, who served for many years as Georgia's agent in London. Franklin Square was also known as Water Tower or Reservoir Square, because of its long-gone landmark, seen here *c.* 1890. Also seen in this image is the First African Baptist Church before it lost its steeple in the hurricane of 1893.

One of the many sites named for Revolutionary War hero Nathanael Greene, Greene Square was laid out in 1799. The first home of the Savannah Female Orphan Asylum, Second African Baptist Church, and the wee Dorsett Cottage all sit on the square. (Photograph taken February 2001.)

Named for South Carolina Royal Governor Robert Johnson, Johnson Square was the first to be laid out by James E. Oglethorpe. It was the site of the public oven and public mill, as well as a forum for the city—hosting political rallies and civic events, such as the official reading of the Declaration of Independence.

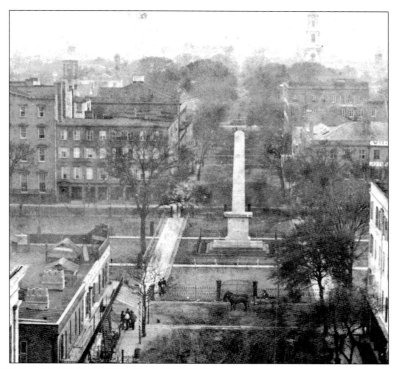

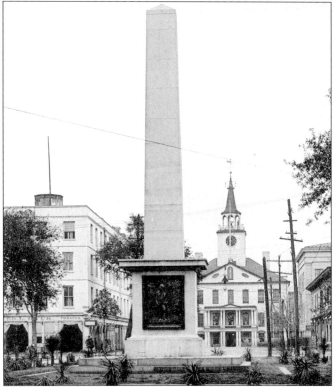

The Marquis de Lafayette laid the cornerstone for the Greene Monument, seen here c. 1900, in Johnson Square in 1825. The monument honors Revolutionary War hero Nathanael Greene, who died of heat stroke at his Savannah River plantation, Mulberry Grove, in 1786. This 50-foot, white marble monument was completed in 1830 according to the design of William Strickland and is the oldest monument in Savannah.

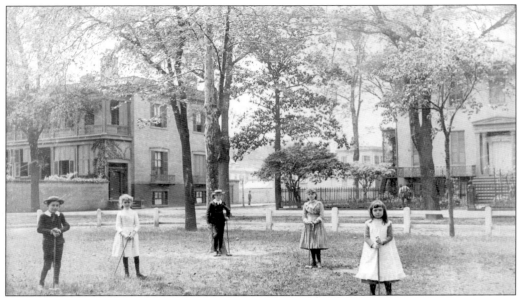

Lafayette Square was laid out in 1837 and named for the Marquis de Lafayette. This square is surrounded by the Andrew Low House, Flannery O'Connor's childhood home, and the Cathedral of St. John the Baptist. The fountain in the center was donated by the National Society of Colonial Dames in the State of Georgia, whose headquarters are in the Andrew Low House. This image of the square dates from 1888 or 1889.

Liberty Square was laid out in 1799 to "perpetuate the dawn of freedom and independence." One of the "Lost Squares," it was consumed by U.S. Highway 17 and the construction of the county courthouse and jail. (Photograph taken February 2001.)

Madison Square, named for President James Madison, was laid out in 1837 and boasts the Green-Meldrim House, the Sorrel-Weed House, the former Savannah Volunteer Guard Armory, the Scottish Rite Temple, and the DeSoto Hilton. The Green-Meldrim House is seen to the right in this *c.* 1940 image.

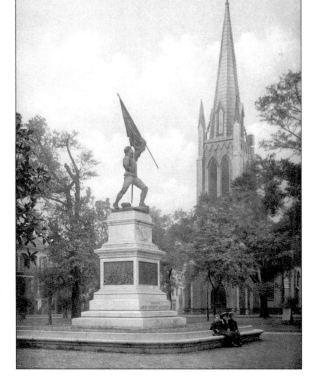

Jasper Monument is a tribute to Sgt. William Jasper of South Carolina, who was mortally wounded bearing the colors of his regiment at the Battle of Savannah in 1779. Designed by Alexander Doyle of New York, the monument was unveiled in 1888 to a crowd that included President and Mrs. Grover Cleveland.

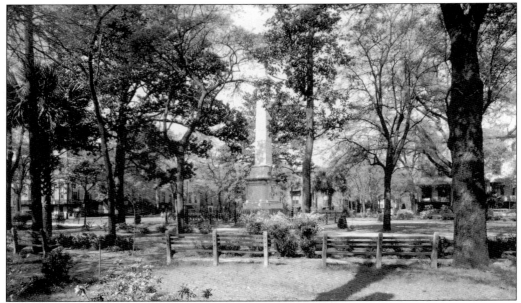

Monterey Square was laid out in 1847, the same year the Jasper Greens, a Savannah military unit, returned from the Mexican War. It was named for the battle that captured Monterey, Mexico. At the center of the square is the Pulaski Monument, dedicated to the Revolutionary War hero Count Casimir Pulaski, who was mortally wounded at the Battle of Savannah in 1779. The monument was unveiled in 1855, and underwent a major restoration from 1996 until 2000.

Originally known as Upper New Square, Oglethorpe Square was later named in honor of James E. Oglethorpe, founder of Georgia. It was one of the first squares to be laid out at the settling of Savannah. Oglethorpe Square is also the site of the first Savannah commission of noted architect William Jay, the Owens-Thomas House.

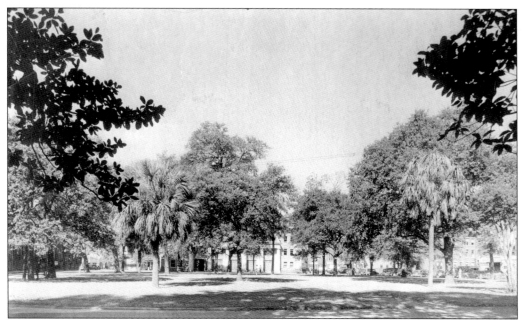

Named in honor of the battle of New Orleans in the War of 1812, Orleans Square was laid out in 1815. The most notable buildings on the square are the Civic Center to the west and the Champion-McAlpin-Fowlkes-Harper House to the east. The square is seen here *c.* 1945.

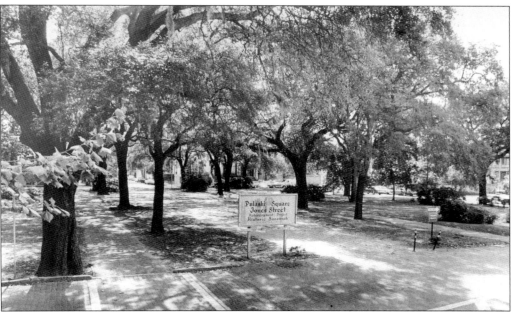

Another site named for Count Casimir Pulaski, Pulaski Square was laid out in 1839. In the 1950s, the deteriorating home of Civil War hero Francis Bartow, which sits on the northeast corner of the square, together with the deplorable condition of the square itself was a wake-up call to preservationists. The sign seen here, *c.* 1965, declares the success of the Historic Savannah Foundation's restoration efforts.

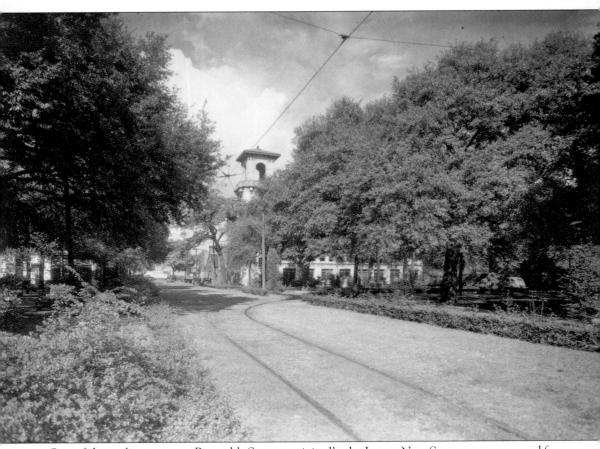

One of the earliest squares, Reynolds Square, originally the Lower New Square, was renamed for Georgia Royal Governor John Reynolds. In the center of the square stands a monument to John Wesley, the founder of Methodism, whose parsonage was located on the square. Also located on the square are the Pink House and the Lucas Theater. Trolley tracks, as those seen here, ran through most squares from the 1890s through World War II.

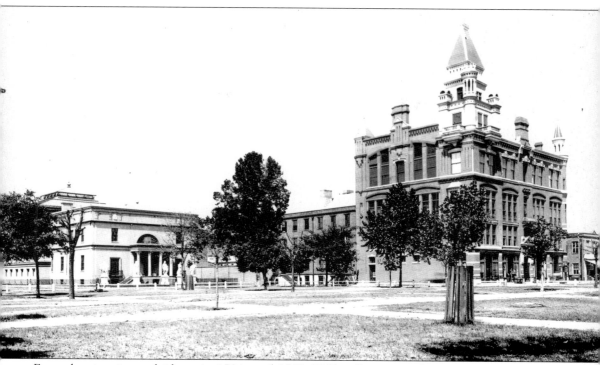

From the time it was laid out in 1734 until 1883, Telfair Square was known as Saint James' Square in honor of the royal residence in London. In 1883, the name was changed to honor the memory of the Telfair family, including three-time governor Edward Telfair and his daughter Mary Telfair, who bequeathed to the city many of the institutions that continue to bear her name, including the Telfair Museum of Art and the Telfair Women's Hospital.

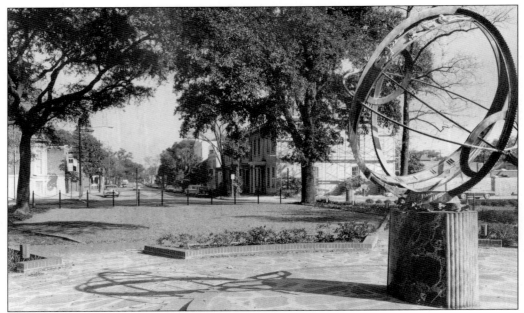

George Michael Troup, U.S. representative, governor, and U.S. senator, was honored with the naming of the square in 1851, five years before his death. The Armillary Sphere, a modern rendition of an ancient astronomical device, graces the center of the square. Its twin is on the campus of Miami University in Ohio.

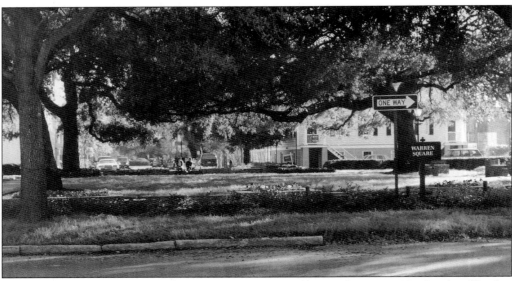

Gunpowder from Savannah made its way to Boston for the Revolutionary War Battle of Bunker Hill, which claimed the life of General Joseph Warren, for whom this square was named. The square was laid out in 1791. (Photograph taken February 2001.)

Among the many squares laid out in 1791, Washington Square is named for Revolutionary War hero and first U.S. president George Washington. Located on this square is the International Seamen's House, operated by the Savannah Port Society, which was incorporated in 1843 "for the purpose of furnishing seamen with regular evangelical ministrations of the gospel and such other religious instructions as may be found practicable." (Photograph taken February 2001.)

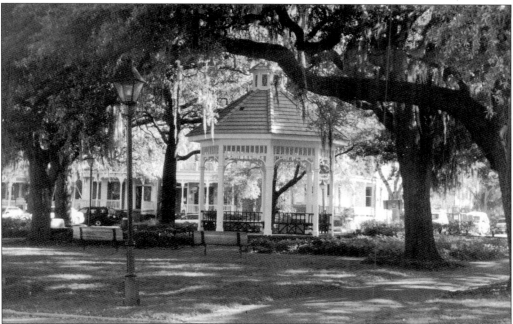

Whitefield Square, laid out in 1851, was the last square established in the historic district. It was named for George Whitefield, who established Bethesda Orphanage. The gazebo at the square's center reflects the Victorian atmosphere of the area. (Photograph taken February 2001.)

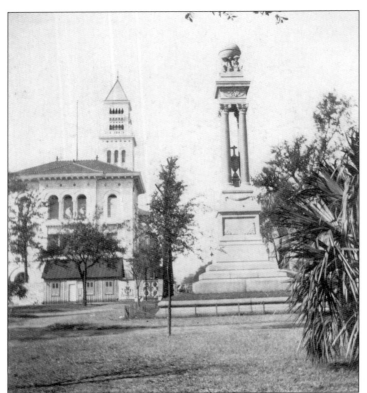

One of the original squares laid out by Oglethorpe, Wright Square is named in honor of James Wright, who served as royal governor of Georgia and attorney general of his native state of South Carolina. Wright Square has also been known as Percival and Court House Square. Two monuments grace Wright Square: one honors William Washington Gordon and the other honors Tomochichi. W.W. Gordon, former mayor of Savannah, was president of the Central of Georgia Railroad, which was instrumental in the development of Georgia's interior.

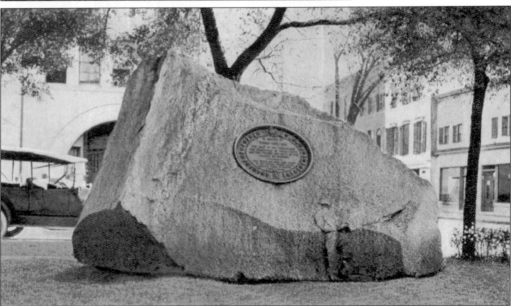

Tomochichi, chief of the Yamacraw Indians, served as interpreter for Oglethorpe and received a state funeral upon his death. His grave was in the center of the square, marked with a pyramid of stones. The stone monument to Tomochichi came from a granite quarry in Stone Mountain, Georgia, and was set in place in 1899.

Six

THE PRIVATE SPHERE

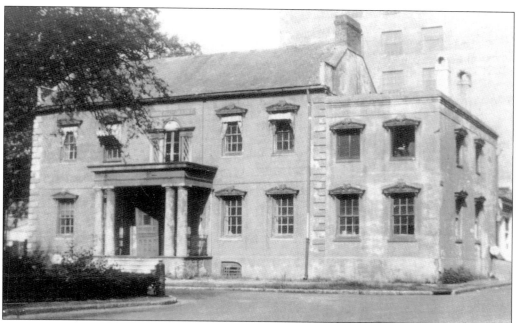

The Pink House (23 Abercorn Street) was built for James Habersham Jr. possibly as early as 1771. For much of the 19th century, the house was occupied by various banks and law firms. The house's name derives from the red clay brick which bled through the white stucco, staining it pink.

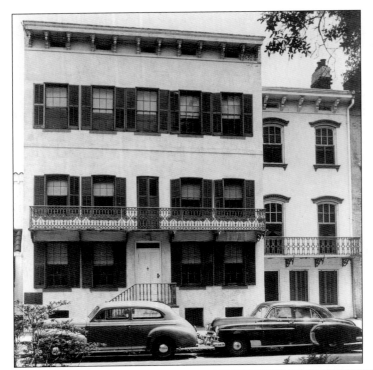

Built *c.* 1764 by brick maker and layer John Eppinger Sr., the Eppinger House (110 E. Oglethorpe Avenue) may be the oldest brick building still standing in Savannah. Originally a tavern, it is said to be the meeting site of the first Georgia state legislature.

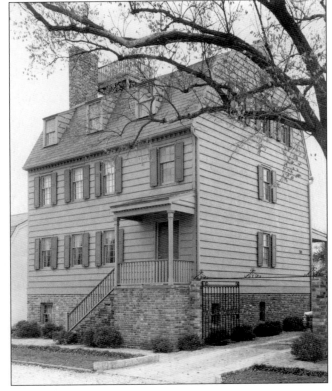

This wood-frame house was built *c.* 1796 at 312 E. Bryan Street for Hampton Lillibridge, a wealthy plantation owner. Jim Williams purchased the house from the Historic Savannah Foundation in 1963 and had it moved to 507 E. St. Julian Street, its present site. Plagued by unexplained noises, Williams had Episcopal priest Rev. Albert R. Stuart conduct an exorcism in 1963.

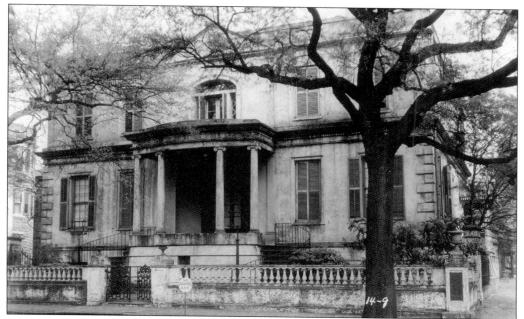

The Owens-Thomas House (124 Abercorn Street) was built in 1817 for Richard Richardson by architect William Jay, a relative of Richardson's wife. The house was Jay's first commission in Savannah. In 1830, George Owens purchased the house. It remained in his family until his granddaughter, Miss Margaret Thomas, bequeathed it to the Telfair Museum of Art in 1951.

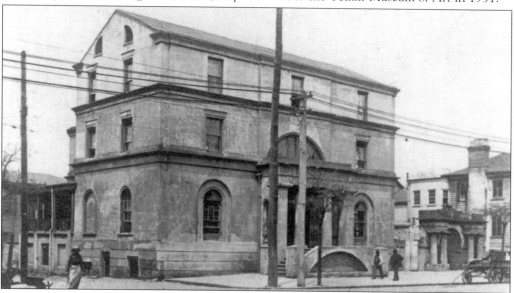

William Scarbrough commissioned William Jay to build this Regency-style house in 1818. Scarbrough was president of the Savannah Steamship Company, which funded the SS *Savannah*, the first steamship to cross the Atlantic Ocean. The Scarbrough House was used as a public school for African Americans from 1878 to 1962. During a 1970s restoration, the third story, which had been added in 1853, was removed. The Scarbrough House (41 Martin Luther King Jr. Boulevard) is now the home of the Ships of the Sea Maritime Museum.

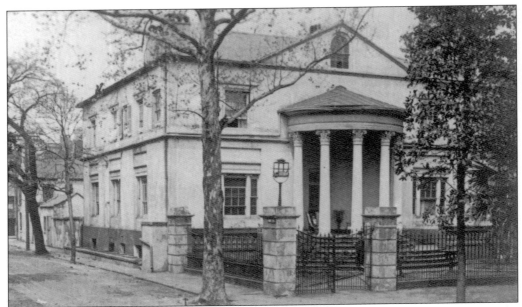

The Bulloch-Habersham House which sat on Orleans Square, was built *c.* 1818–1820 by William Jay for Archibald S. Bulloch, a Savannah merchant. After the depression of 1820, during which Bulloch lost the house, it became an upscale boarding house. In 1833–1834, Robert Habersham acquired the house.

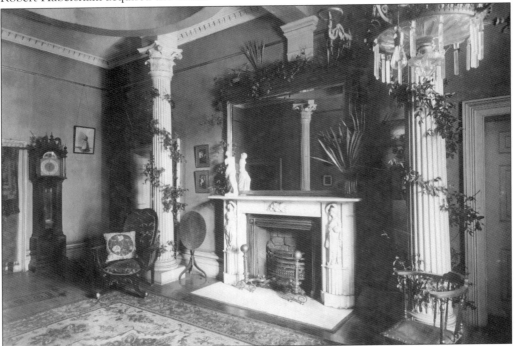

This interior view of the Bulloch-Habersham House was taken shortly before it was demolished in 1916 to make way for the City Auditorium. Many of the decorative elements and fixtures were sold at auction and were reused on other properties around town.

Isaiah Davenport built the Federal style–Davenport House (324 E. State Street) of brick and brownstone in 1820. A Rhode Island native and Savannah builder, Davenport also built the martello tower at Tybee Island. By the 1930s, the house had been broken up into many small apartments.

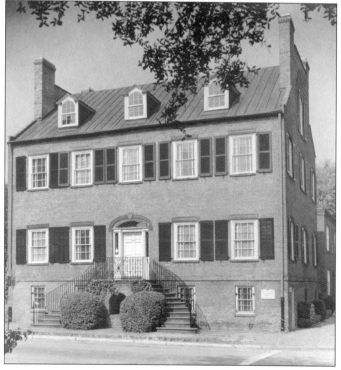

In 1955, the Davenport House was threatened with demolition to make way for a parking lot. Anna Colquitt Hunter organized local women and raised $22,500 in 24 hours to purchase and protect the house. This was the galvanizing event which launched Savannah's preservation effort as well as the beginning of the Historic Savannah Foundation, which has used its revolving fund to purchase properties in danger of being lost.

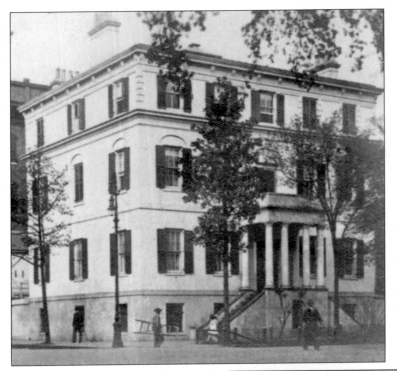

The Juliette Gordon Low Birthplace (10 E. Oglethorpe Avenue) is attributed to William Jay, with additions in 1886 by Detlef Lienau. Juliette Gordon Low founded the Girl Scouts of America, which operates the house as an historic site.

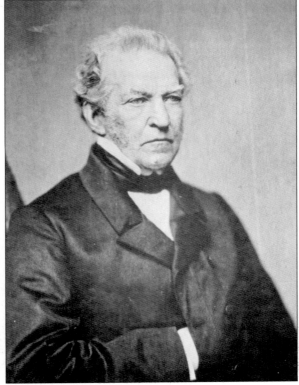

The Wayne-Gordon house at 10 E. Oglethorpe Avenue was built *c.* 1820 for future United States Supreme Court Justice James Moore Wayne, who also served as mayor of Savannah and U.S. congressman. Juliette Gordon Low was Wayne's great-niece.

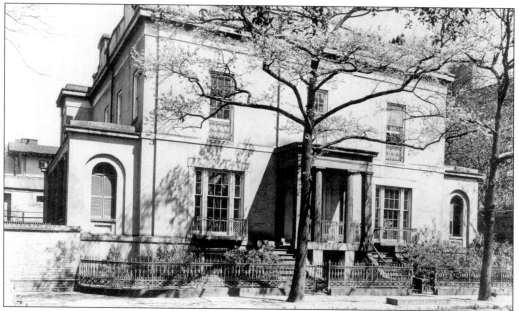

In 1841, Charles B. Cluskey built the Sorrel-Weed House (6 W. Harris Street) for Francis Sorrel, a merchant who had recently moved to Savannah from Santo Domingo. Henry Davis Weed acquired the house in 1859. The vibrant pumpkin color of the house is similar to a shade uncovered during restoration, although paint pigments and weathering patterns would have yielded a more muted shade for the original layer.

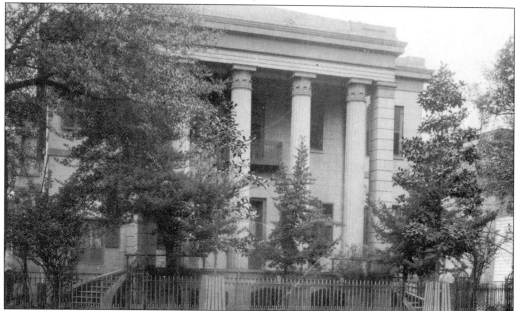

The Champion-McAlpin House (230 Barnard Street) was designed by architect Charles B. Cluskey for Aaron Champion in 1843. Champion's daughter married Henry McAlpin's son, thus passing the house into the McAlpin family. In 1939, Alida Harper Fowlkes purchased the house and later bequeathed it to the Society of Cincinnati, Georgia Chapter.

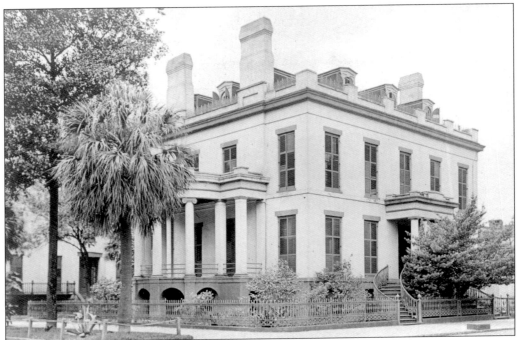

Local silversmith Moses Eastman commissioned this house from Charles B. Cluskey in 1844. Joseph Hull bought it in 1893. In 1911, Henrik Wallin designed the third-floor addition. This view of the Eastman-Hull-Stoddard-Barrow House (17 W. McDonough Street) dates from 1910.

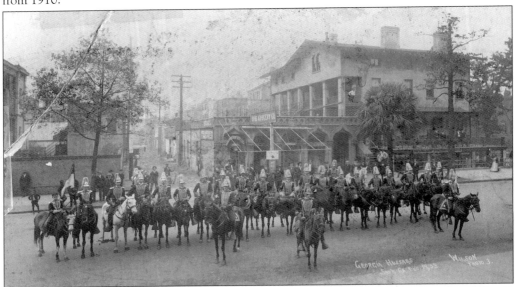

Number 1–3 E. Liberty Street was built in 1849 for Joseph S. Fay, and attributed to John S. Norris. George Wymberley Jones DeRenne lived here from 1871 to 1890, after which time the Georgia Hussars purchased it for their club rooms. It is currently the home of the Knights of Columbus. This 1908 photograph by M. Edward Wilson shows the Georgia Hussars in front of their club house in the right background.

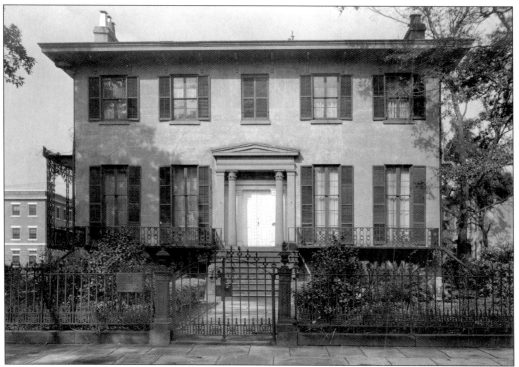

John S. Norris built the Andrew Low House (329 Abercorn Street) in 1849 for English cotton factor Andrew Low. Andrew's son, William Mackay Low, married Juliette Gordon. Juliette held the first meetings of the Girl Scouts of America in the carriage house seen below. It is now owned by the National Society of Colonial Dames in the State of Georgia, whose first president was Juliette's mother, Nellie Kinzie Gordon.

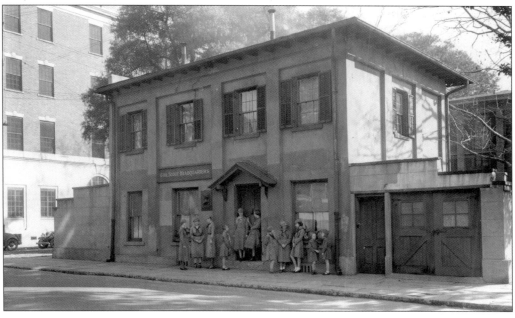

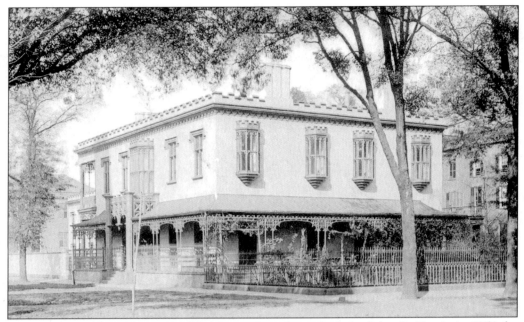

The Green-Meldrim House (14 W. Macon Street) was built by John S. Norris in 1853 for Charles Green, an English cotton factor. In 1893, the house was sold to Judge Peter Meldrim. St. John's Episcopal Church acquired the house in 1943 for use as a rectory.

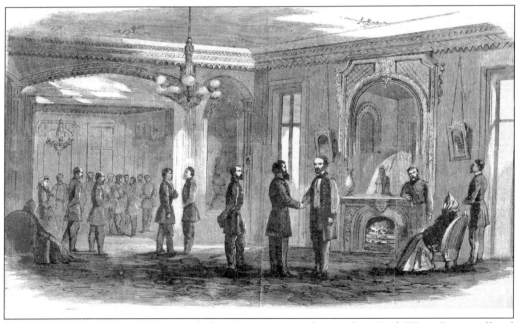

During the occupation of Savannah by Union troops during the Civil War, Green offered his home to Gen. William T. Sherman for use as his headquarters. On January 28, 1865, *Harper's Weekly* had the following: "New-Year's Day in Savannah- General Sherman's Reception at Mr. Green's."

The population of Savannah doubled between 1830 and 1850, increasing the demand for housing. Mary Marshall, owner of the Marshall Hotel on Broughton Street, built these Savannah grey brick row houses in 1855–1856. Marshall Row (200 block E. Oglethorpe Avenue) was the childhood home of poet Conrad Aiken.

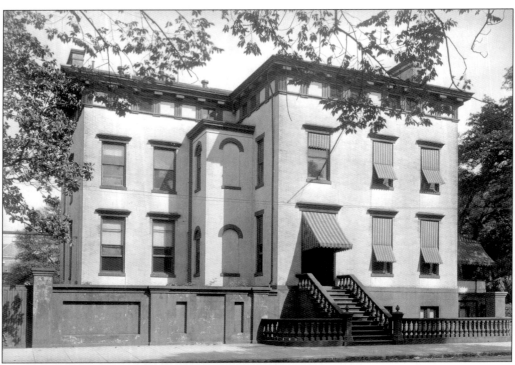

Currently owned by the Oglethorpe Club for exclusive use by its members, 450 Bull Street is also known as the Molyneux-Jackson House. In 1857, it was built for British consul, Edmund Molyneux.

After the Civil War, the Molyneux House was purchased by Henry Rootes Jackson—poet, soldier, lawyer, diplomat, and president of the Georgia Historical Society. Jackson was the prosecuting attorney in the 1859 case of the slave ship *Wanderer*, which violated the Slave Trade Acts, banning imports of African slaves to the United States.

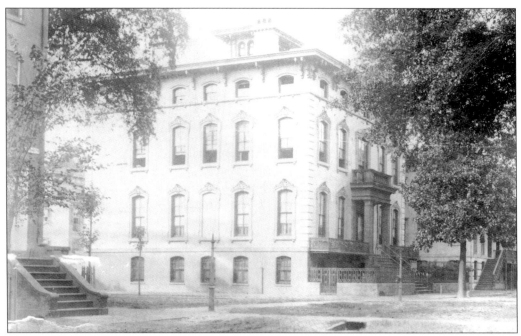

Construction on the Hardee House (3 W. Gordon Street) began in 1860, but was suspended during the Civil War. The Italianate-style house was built for Noble A. Hardee. In 1945, it was acquired by Armstrong College for additional classroom space. In 1972, it became a private residence once more.

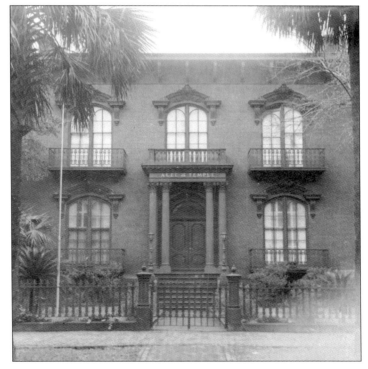

Designed in 1860 by John S. Norris for Gen. Hugh W. Mercer, the Mercer House (429 Bull Street) was not completed until 1871. Hugh Mercer was the grandfather of singer–songwriter Johnny Mercer. In the 1970s, the house was purchased from the Shriners by Jim Williams, a local antiques dealer and restorer. The house became famous as the site of Danny Hansford's death as chronicled in John Berendt's *Midnight in the Garden of Good and Evil.*

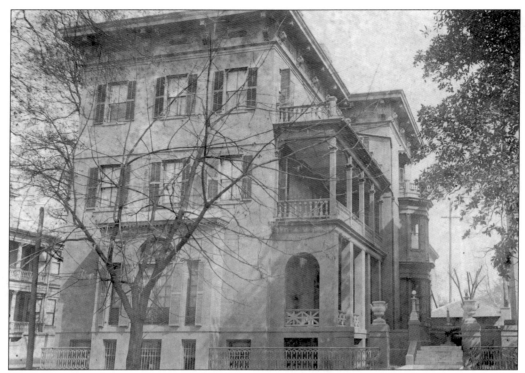

The Minis-Quattlebaum House (24 W. Gaston Street) was built in 1861–1862 for George S. Gray. Originally, it was unstuccoed brick; however, in 1874, Judge Walter Chisholm renovated it and applied its stucco facing. Subsequent owners include the Minis family, who purchased it in 1905, the Quattlebaum family after 1939, and Armstrong College, which sold it after the campus moved to the southside.

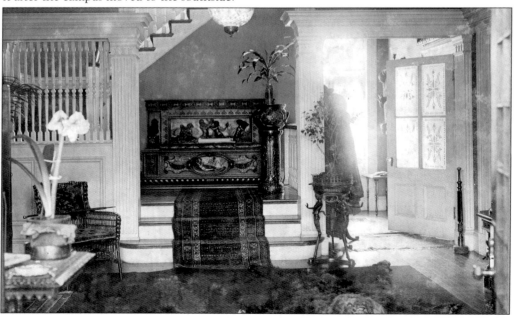

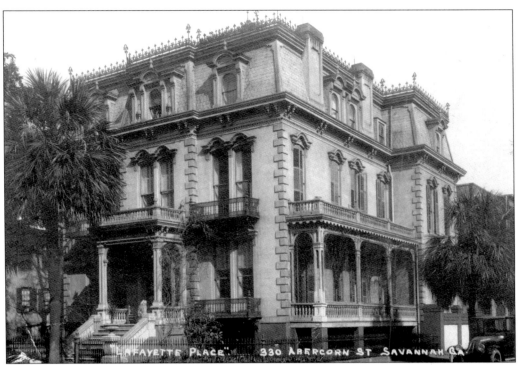

The Hamilton-Turner House (330 Abercorn Street) was built in 1873 for Savannah jeweler Samuel P. Hamilton. Built of Savannah grey brick covered with stucco, the house cost between $75,000 and $100,000, with an additional $50,000 in furnishings. It was one of the first houses in Savannah to be wired for electric lights around 1880.

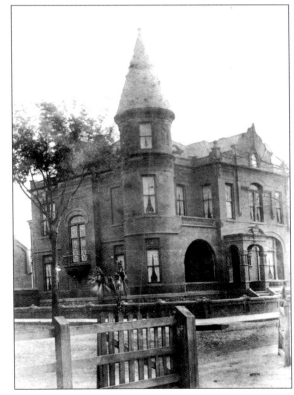

The Kayton House (700 Drayton Street) was built of brick and terra cotta in 1887 by Alfred S. Eichberg. The house is currently owned by Fox and Weeks Funeral Home.

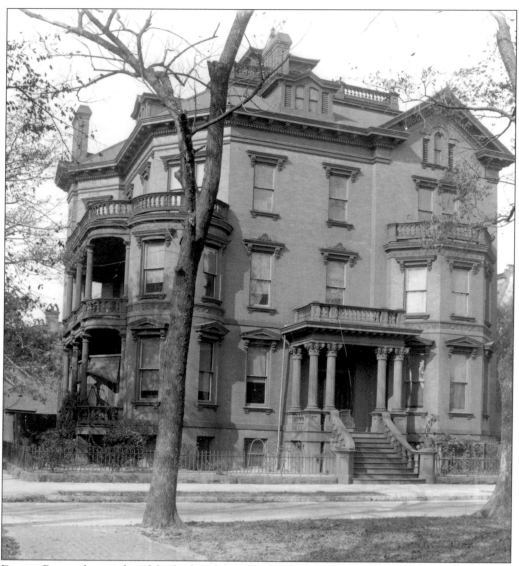

Dewitt Bruyn designed and built the Kehoe House (123 Habersham Street), a brick, Queen Anne–style house, between 1892 and 1894 for William Kehoe, owner of Kehoe Ironworks. Most of the exterior decorative elements are made of iron.

Seven

THE PUBLIC SPHERE

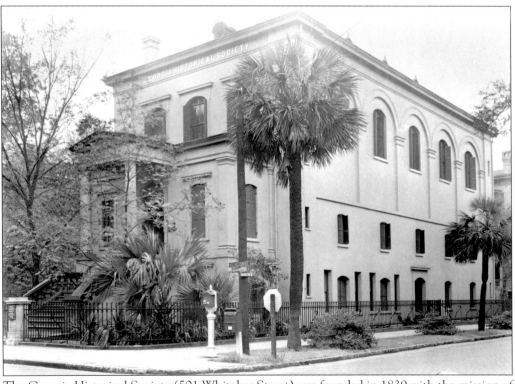

The Georgia Historical Society (501 Whitaker Street) was founded in 1839 with the mission of "collecting, preserving, and diffusing information relative to the history of the state of Georgia." Hodgson Hall, the current headquarters of the Georgia Historical Society, was built in 1875–1876 by Margaret Telfair Hodgson and her sister Mary Telfair, to honor Margaret's husband William B. Hodgson.

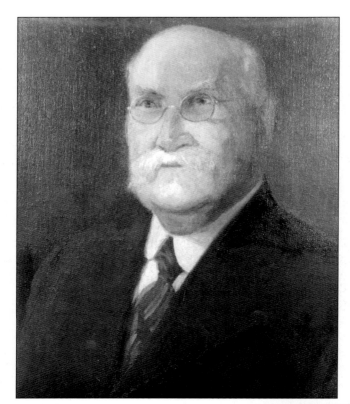

William Harden served as the librarian at the Georgia Historical Society from 1866 until 1932. He also served as secretary for the Georgia Historical Society, public librarian for Savannah, founding member of the American Library Association, secretary for the Society of the Cincinnati, commander of the United Confederate Veterans, and organizer of the Georgia Society of the Sons of the Revolution. He was a member of the Georgia Bar, served in the County Treasurer's office for 53 years, and was a member of innumerable historical, literary, civic, and social societies.

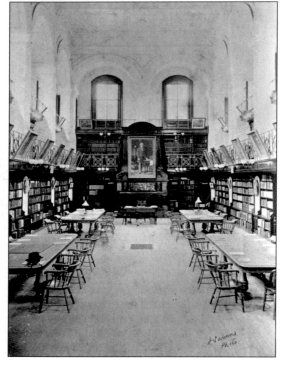

Hodgson Hall is the third building occupied by the Georgia Historical Society. This interior view was taken in 1876, the year it was dedicated. In 1970, a three-story annex was added to provide additional storage for the Society's growing collections. In 1980, the annex was renovated to provide even more space for collections.

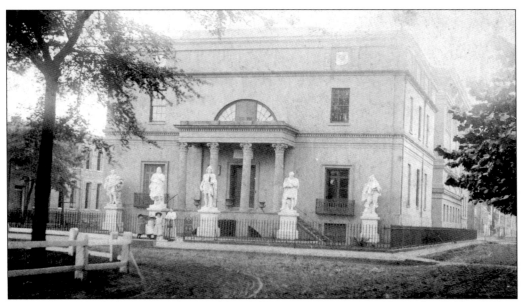

This Regency-style home was designed by William Jay in 1820 for Alexander Telfair. When Telfair died in 1875, the home passed to his sisters, Mary and Margaret. Mary Telfair's will established the Telfair Academy of Arts and Sciences, under the trusteeship of the Georgia Historical Society. The Academy, opened in 1885 in the Telfair mansion, is now called the Telfair Museum of Art. The date of the photograph of the house, shown above, is 1888. The photograph of the cast room, shown below, dates from the 1880s.

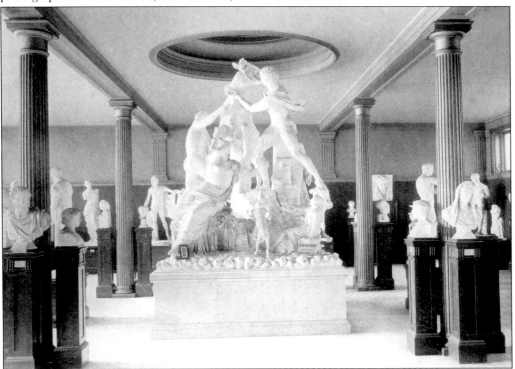

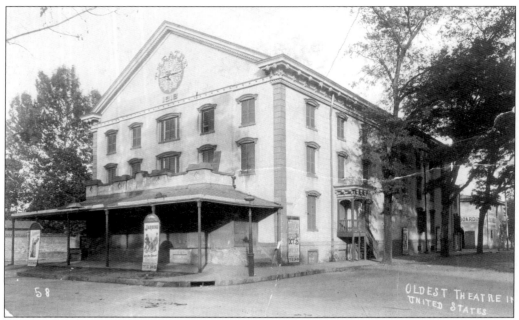

The Savannah Theater on Chippewa Square is another William Jay commission, this one built in 1818. It was remodeled in 1906 after a fire and again in 1931 when it was converted to a movie theater. It is the second-oldest continuously operating theater in America.

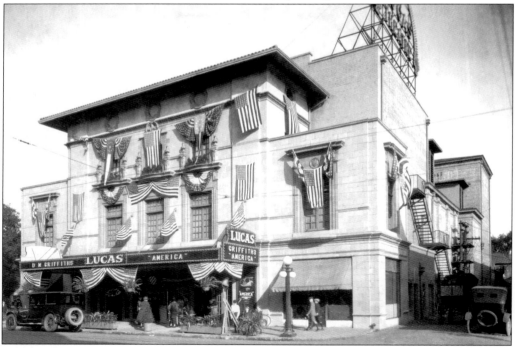

Built in 1921 by C.K. Howell for Col. Arthur Lucas, the Lucas Theater (32 Abercorn Street) served as a vaudeville and cinema house until it closed in 1976 for extensive restorations. It reopened in December 2000.

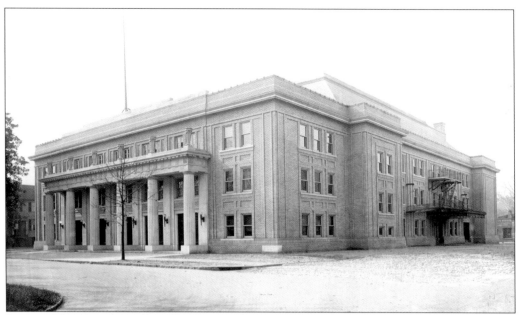

Designed by Henrik Wallin, the City Auditorium on Orleans Square opened in November 1917 and seated 3000. It was razed to make way for the Savannah Civic Center, which opened in February 1972.

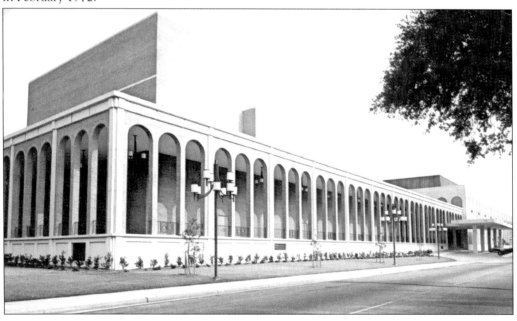

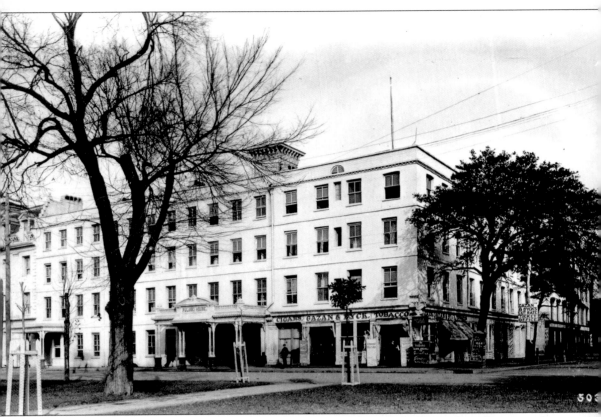

Although there is no exact date for the construction of the Pulaski House (hotel), it may date from as early as 1795. In the 1880s, the Pulaski House was managed by W.J. Watson whose daughter, Gracie, contracted pneumonia and died two days after Easter 1889. Her life-like marker is among the most visited at Bonaventure Cemetery. The next year, the Watsons became the managers of the newly opened DeSoto Hotel. The Pulaski House, on the northwest corner of Johnson Square, was torn down in 1957 and replaced with a cafeteria. It is seen here *c.* 1890.

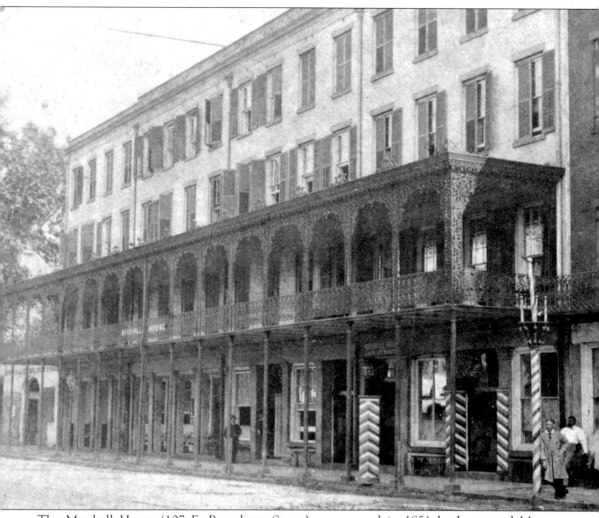

The Marshall House (107 E. Broughton Street) was opened in 1851 by James and Mary Marshall who operated the hotel until 1894. In 1857, the signature cast-iron veranda was added to the Broughton Street facade. The hotel operated as the Geiger Hotel and the Gilbert Hotel, until it was closed in 1957. In 1999, the Marshall House reopened after extensive restorations, including the re-creation of the iron veranda.

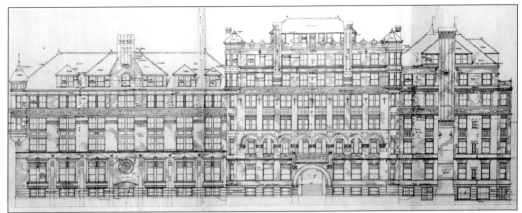

Designed by William G. Preston, the DeSoto Hotel was constructed of brick, stone, and terra cotta. It cost more than $500,000 to build and furnish. Above is Preston's Liberty Street elevation. Below is a view of the construction site taken shortly after the 1889 fire which devastated much of the city, but spared the hotel.

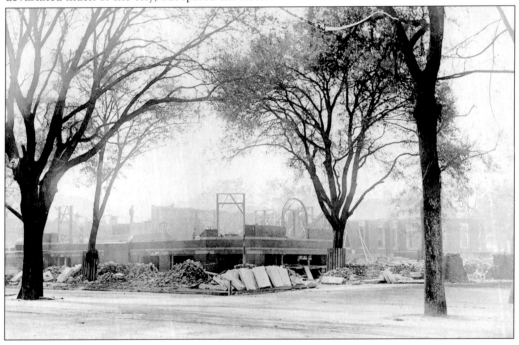

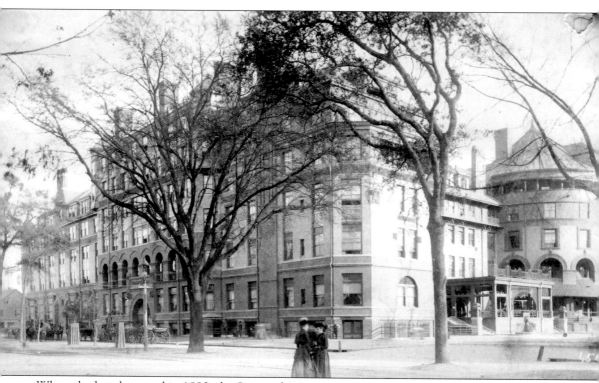

When the hotel opened in 1890, the *Savannah Morning News* reported, "Savannah's new hotel, the DeSoto, is completed and ready for the reception of guests. It is a splendid building, superbly furnished, and the people of Savannah are proud of it. It is the chief ornament of the city. It would be an ornament to any city."

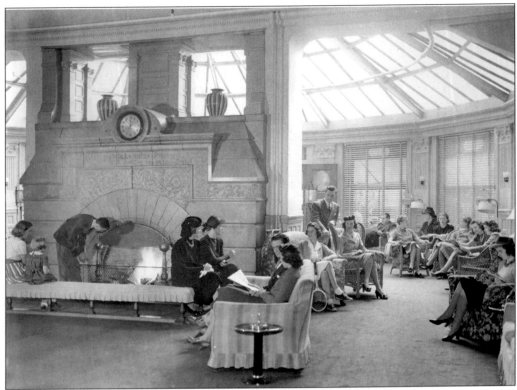

The DeSoto Hotel was built to accommodate 500 guests and had extensive verandas, a solarium, lounges, restaurants, and numerous theme suites. The image above was taken in 1939. Below is a 1929 view of the "Hit The Deck" suite which commemorates Savannah's ties to the sea. The room featured portholes, hammocks, life preservers, and port and starboard lights.

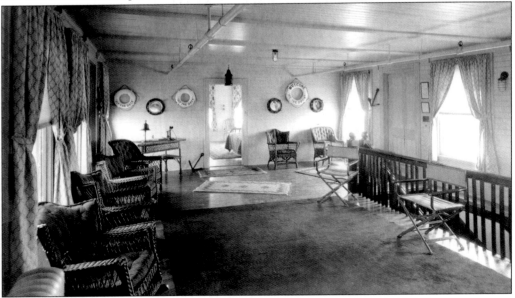

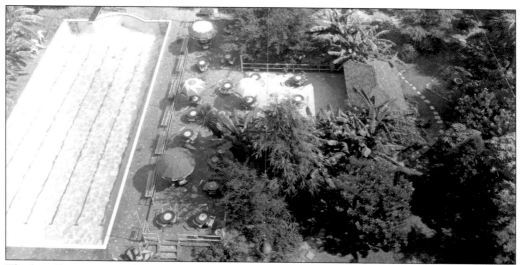

The hotel's promotional literature boasted, "The swimming pool is the most modern of its kind in this section. Its 90,000 gallons of clear, sparkling water reflecting the blue from the open sky overhead, cannot be resisted and our guests while away many an hour in its depth." The pool measured 30 by 75 feet, had a diving board, and was illuminated at night.

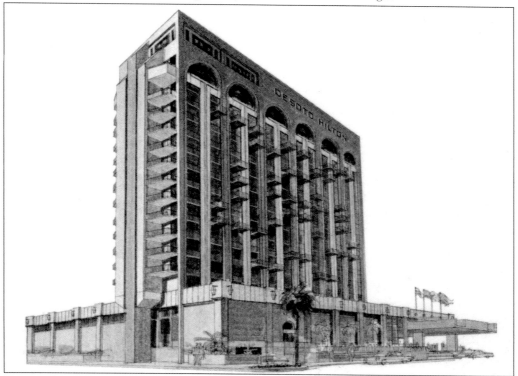

In 1966 the DeSoto Hotel was demolished to make way for the DeSoto Hilton which opened in 1967. A porter was quoted in the *Atlanta Journal and Constitution* as saying, "The old folks around town hate to see it torn down, but you have to compete with the motels these days. The people want air conditioning."

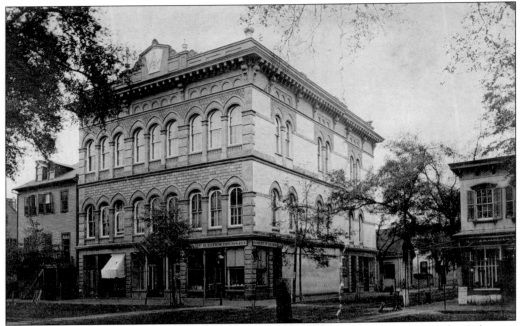

The Masonic Temple, on the corner of Liberty and Whitaker, was built *c.* 1858. The Solomon Lodge of Freemasons, Grand Lodge of the State of Georgia was chartered in 1735. The first meeting of the Grand Lodge was held in Savannah in 1786. Solomon's Lodge currently occupies the Savannah Cotton Exchange.

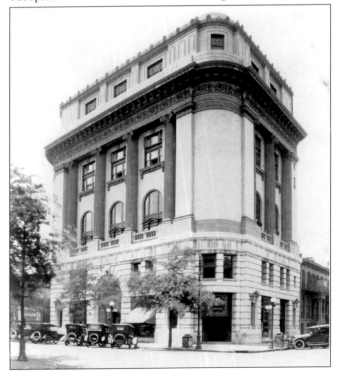

In 1912, Hyman W. Witcover designed and built the Scottish Rite Temple—seen here *c.* 1930—on Madison Square. On the ground floor was Solomon's Drug Store. When it closed in 1981, it was one of the oldest drug stores in the country. It is now the Gryphon Tea Room, operated by the Savannah College of Art and Design.

William Bergen designed Drayton Towers as his senior thesis at Georgia Technical University. When he graduated in 1948, he went to work for his father's architecture firm and Drayton Towers was built soon after. An eyesore to some, Drayton Towers is a fine example of the International Style of architecture. It is located on the corner of Drayton and Liberty Streets.

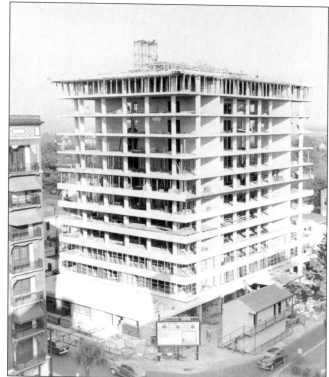

The U.S. Marine Hospital (115 E. York Street) opened in November 1907. Originally, the hospital provided care for U.S. government workers. It is now the Westside Urban Health Center.

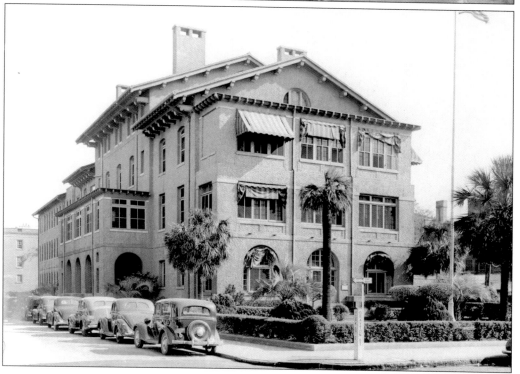

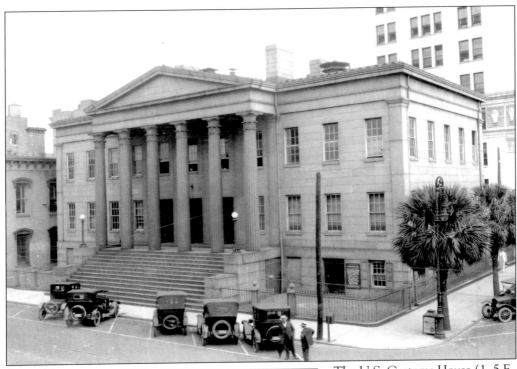

The U.S. Customs House (1–5 E. Bay Street) sits on the site of James E. Oglethorpe's headquarters in Savannah. Built between 1847 and 1852 by John S. Norris, the Greek Revival Customs House is made of granite imported from Massachusetts. During the 19th century, federal court was held here, including the case of the slave ship *Wanderer*.

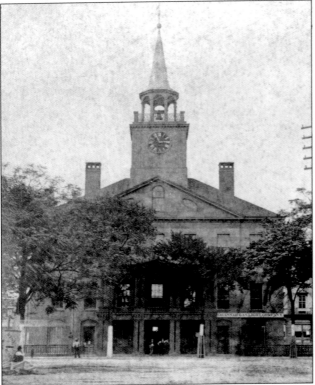

Completed in 1812, the City Exchange was built according to the designs of Frenchman Adrian Boucher. The City Exchange served both public and private interests until 1812 when the City of Savannah acquired the building for use as City Hall. The Exchange sat on Bay Street at the head of Bull Street

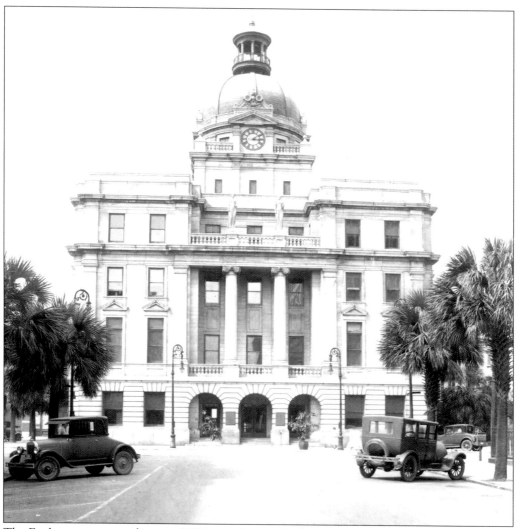

The Exchange was torn down in 1904 to make way for the current city hall building, which was designed by Hyman W. Witcover in 1905. Mayor Herman Myers reported, "It will typify the twentieth century Savannah, the Savannah of indomitable energy, of pushing progressiveness."

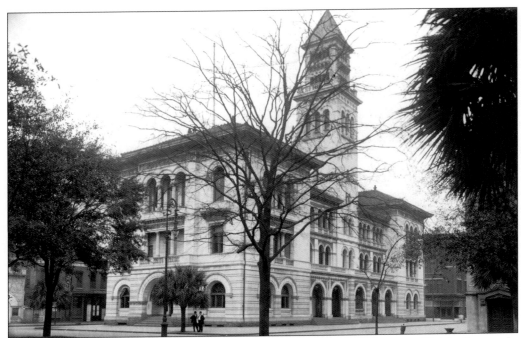

Built in 1898 by architect William Aiken, the former U.S. Post Office sits on Wright Square. In 1931, the building was enlarged under the supervision of James A. Wetmore. The building is constructed of Georgia marble. Viewed from the square, the building's tower seems off center; this is because the original building, including the tower, was oriented to sit perpendicular to Wright Square. When the addition was made, the orientation changed to face the square.

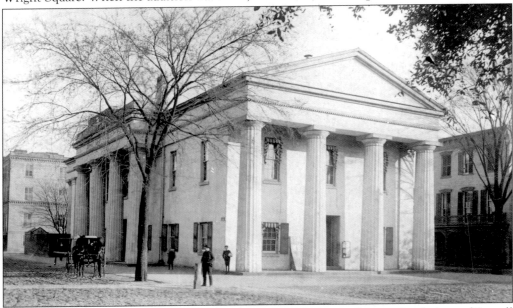

The Chatham County Courthouse was built in 1830–1833 according to the designs of Russell Warren Tallman and Buckling of Providence, Rhode Island. The courthouse, seen above, was photographed by William E. Wilson shortly before its demolition in the 1880s.

William Gibbons Preston came to Savannah from Boston in 1889 to design the second Chatham County Courthouse. The courthouse, built on the same site as the earlier one (124 Bull Street), is in the Romanesque-revival style. The current Chatham County Courthouse, on Montgomery Street, was built and dedicated in 1979.

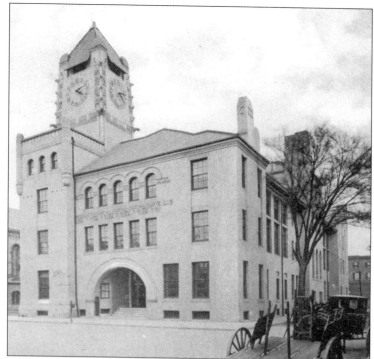

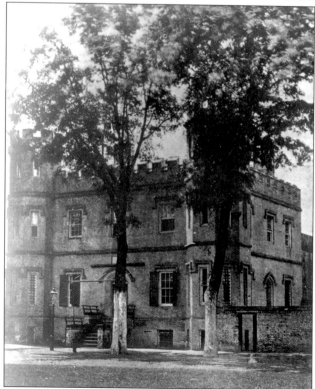

The second city jail, seen here, was built on W. Hall Street in 1845 and later demolished. It was replaced in 1887 by the jail located at Habersham and Perry Lane, which was designed by the McDonald brothers. It served as the city jail until the current jail building was constructed as part of the Chatham County Courthouse Complex on Montgomery Street in the 1970s.

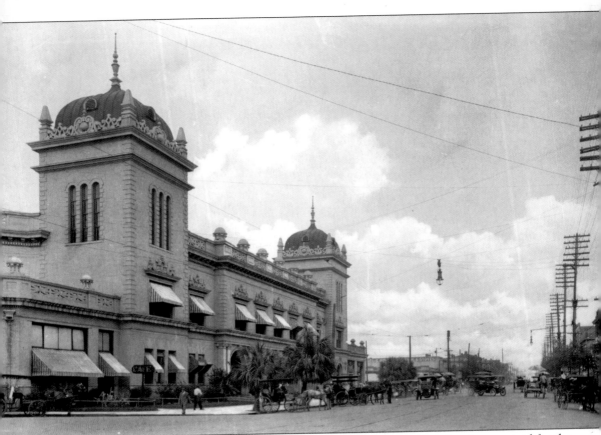

In 1899, Union Station was erected at a cost of $200,000 and served as the city terminal for the Seaboard Air Line Railway until it was closed in August 1962. The station sat on Martin Luther King Jr. Boulevard (formerly W. Broad Street) and was demolished to provide entry to Interstate 16.

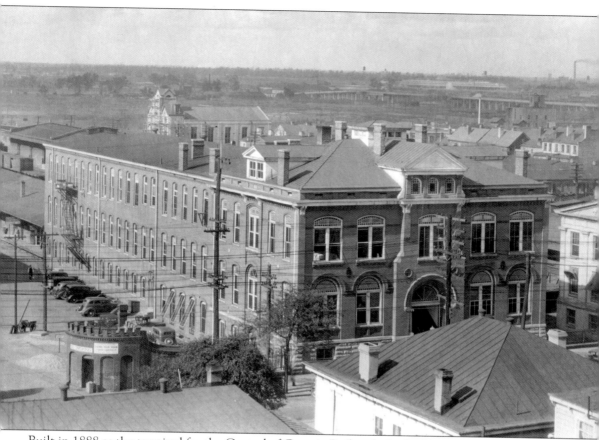

Built in 1888 as the terminal for the Central of Georgia Railroad, this building was designed by Calvin Fay and Alfred S. Eichberg. Known as the "Red Building," it served as the administrative headquarters of the Central of Georgia Railroad. Since the mid–1970s, the building has served as the Visitor's Center for the City of Savannah (233 Martin Luther King Jr. Boulevard).

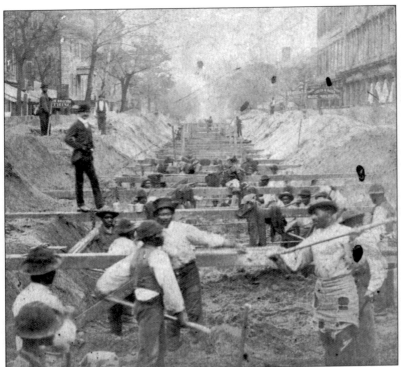

Following the 1854 yellow fever epidemic, the city council instructed the city surveyor to estimate the cost of a sewer and drainage system. In 1860, Mayor Richard D. Arnold remarked, "The system of sewerage and drainage, thus commenced, is of vast importance in a sanitary point of view." This undated view of Broughton Street shows the scope of such sewer projects.

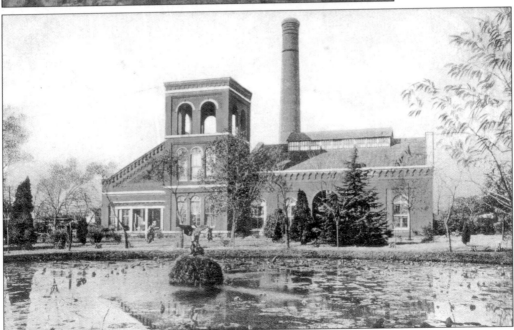

In 1851, a survey was presented to city council advocating the Savannah River as a source for the city's water supply. The river served as the city's main source of water from 1854 to 1892, when an artesian-well system was adopted. The City Waterworks, pictured here, were located on Stiles Avenue on the westside of Savannah.

The paving of streets in Savannah began in earnest during the 1930s when the Works Progress Administration and the Public Works Administration provided the funds to do so. Prior to modern paving, Savannah's streets were sand, plank, stone, and brick. This undated image shows the paving of Jones Street.

The first streetcar company, the Savannah, Skidaway and Seaboard Railroad Company, was chartered by the General Assembly of the State of Georgia in 1866. The first horse-drawn streetcars made their debut in January 1869. The first electric-powered streetcars ran in Savannah in 1890 and continued until 1946 when buses replaced the trolleys.

This nighttime view of Broughton Street dates from about the 1920s. On September 25, 1882, Savannah's streets were illuminated by electric lights for the first time. Prior to 1850, the streets had been lit by oil lamps; from 1850 to 1882 the lamps were fueled by gas.

INDEX